SECRET DARTMOUTH

Christine Donnelly

AMBERLEY

About the Author

Christine Donnelly lives in Devon. She has had a lifelong interest in the paranormal and parapsychology and has also written a book called *The Ghosts of Dartmouth*, as well as writing articles on the subject for a local newspaper.

First published 2021

Amberley Publishing
The Hill, Stroud
Gloucestershire, GL5 4EP

www.amberley-books.com

British Library Cataloguing in Publication Data.
A catalogue record for this book is available from the British Library.

ISBN 978 1 3981 0410 5 (print)
ISBN 978 1 3981 0411 2 (ebook)

Origination by Amberley Publishing.
Printed in Great Britain.

Contents

Introduction

When I was asked to write *Secret Dartmouth*, I sat back and pondered about the mammoth task ahead. There is so much history attached to the town that it was difficult to know where to start. It has an enchantment which is hard to capture in words. Visitors from all over the world are attracted to the town to experience its quaint atmosphere and welcoming hospitality.

Dartmouth is steeped in history and secrets. Wandering down its ancient streets, you get a sense of being slowly drawn into its colourful past. Royalty and film stars are all part of its fabric, along with pirates, ancient mariners, castles, inventors and even some friendly ghosts. The sea has always played a big part in the lives of the people of Dartmouth, who worked as seamen, fishermen, earning money for the rich merchants, building ships and working as coal lumpers in the days of the steam ships. Secret coves wait to be discovered by inquisitive tourists and all types of sailing vessels can be accommodated in the deep-water harbour – even the modern cruise ships of today – all watched over by a mermaid called Miranda, who sits on a rock, silently welcoming all.

The people of Dartmouth are very proud of their town, and rightly so. It was host to the Pilgrim Fathers who set sail on the *Mayflower* and sailed into Dartmouth to make repairs to the *Speedwell*, the ship accompanying it on its voyage to America. It is the birthplace of the Newcomen atmospheric steam engine, an example of which, the only remaining working model of its kind, can be seen at the Dartmouth Visitors Centre.

The Dartmouth Regatta has always been a huge favourite with tourists. The first regatta took place in 1822 and became formally established in 1834. The regatta became known as the Dartmouth Royal Regatta, after Queen Victoria paid a visit in 1856 and bequeathed the title upon the town. The regatta in the 1930s had people flocking into the town, bringing with it much-needed wealth with added excitement. Apart from the boat races, there were also swimming races, which meant everyone had a chance to join in the fun. During one of these regattas, flying boats took part, and there would always be a fair and sometimes a circus. Until recent years the Red Arrows display team have delighted thousands with their daredevil aerobatics, which signalled the end of the regatta for that year.

The Royal Britannia Naval College nestles on the hillside overlooking the river and has, in its time, provided the rare opportunity for a young royal romance. Dartmouth has been the home of the Royal Navy since the reign of Edward III.

So please, sit back, make yourself comfortable and join me on a journey through secretive and mysterious Dartmouth.

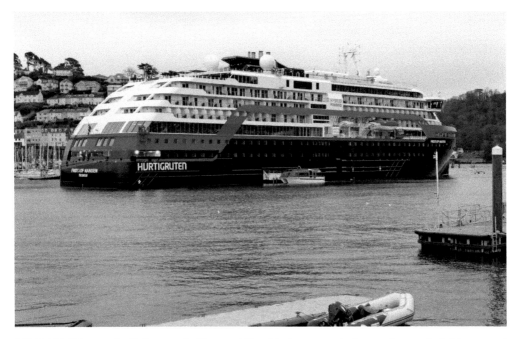

MS *Fridtjof Nansen*, built in 2020 in Norway. The ship has a revolutionary battery hybrid-powered propulsion system and is named after the Norwegian explorer, scientist and Nobel Peace Prize winner. It is seen here in port at Dartmouth, March 2020.

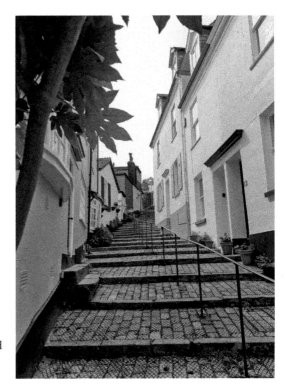

Browns Steps. This was the original road down into the town. The top of the steps led to St Clement's Church, the mother church of Dartmouth.

1. Historic Dartmouth

Early History

There has been evidence of settlements around Dartmouth as far back as the Mesolithic period between 10,000 and 4,000 years ago. The embankment has revealed some very interesting artefacts which has led to proof of an early occupation. Tools such as flints have been found, hidden over the decades, waiting to be discovered.

Primitive settlements were established by the Celts on the riverbanks and surrounding hills. The Romans invaded in the first century and settled amongst the Celts. As time went on the Celts began to accept the Roman occupation and eventually began to work alongside them. This continued until the fifth century AD, at which time the Romans departed from the settlements and the Celts were left alone and became vulnerable to Saxon raids. This unsettled period lasted until around the eighth century, when the Vikings sailed into the Dart and began to cause mayhem.

DID YOU KNOW?
The legendary leader of the Trojans, Brutus, is said to have sailed into the mouth of the Dart, with a fleet laden with treasure on his way to Totnes. There is a bridge in Totnes, just further down the river from Dartmouth, named after him – Brutus Bridge.

Dartmouth has its first mention as a settlement in the Domesday Book. This book contained the details of the people who owned all the land and property in the country and was commissioned by William the Conqueror who wanted to impose taxes. It was known as Dunestal, which now makes up the parish of Dartmouth. It was under the control of Walter of Douai and tax was paid on half a hide, the settlement consisted of 'two plough teams, two slaves, four smallholders and five villagers. Livestock consisted of six cattle, fifteen goats and forty sheep'. The settlement became known as Townstal, which appeared to be predominately agricultural and based itself around the church.

After that time, Dartmouth, as it became to be known, underwent a rapid development and by the twelfth century a fleet of 146 ships assembled around Warfleet Creek, which lies just inside the mouth of the River Dart, ready to set out on the Second Crusade in 1147 and again in 1190. At the time of the Third Crusade more than a hundred vessels were said to have arrived there. It may be because of these events that the name Warfleet Creek arose, although this has since been disputed by local historians.

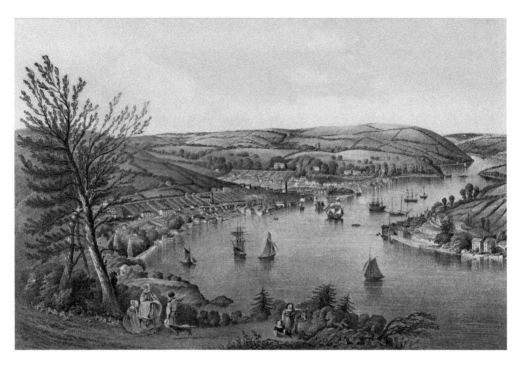

Above: Dartmouth *c.* 1720.
(B. Morris Collection)

Right: Warfleet.

Dartmouth began to expand and by the fourteenth century an enviable trade in wine with English-owned lands in Gascony began to swell the coffers of the Dartmouth merchants. This led to the King awarding the town a charter of incorporation in 1341.

DID YOU KNOW?
Captain James Cook was thought to have stopped at Dartmouth on his way to Australia.

Walter Raleigh was very busy capturing Spanish ships filled with treasure, some of which he brought back to Dartmouth. It was with the help of ships from Dartmouth that he defeated the Spanish Armada. In 1588, the Spanish ship *Nuestra Senora del Rosario* was captured and brought back to Dartmouth, bringing with it much wealth, in pearls, gold and exotic silks. It is also thought that some of the crew that had been captured were sent to work on the land at Greenway, under the orders of Sir Humphrey Gilbert, Sir Walter Raleigh's half-brother.

In 1620 a group of Puritans, later to become known as the Pilgrim Fathers, began a voyage to America. They bought a ship, fitted out in Holland, called the *Speedwell* and hired a ship from London called the *Mayflower*. The ship was to sail from Southampton, across the Atlantic Ocean and arrive in America, where the settlers would build homes for them to live in. Soon after the voyage began, the *Speedwell* began to take in water and both the *Speedwell* and the *Mayflower* sailed into Dartmouth so that repairs could be made. The ships were docked in Dartmouth for several days and this took a heavy toll on the supply of food that they had, which was supposed to be used on the voyage. After certain repairs were made, both the ships set sail again and continued on their voyage. Unfortunately, the *Speedwell* continued to leak water and so it was sailed to Plymouth and moored up there. The crew and passengers then boarded the *Mayflower* and the voyage continued.

The Plague Comes to Dartmouth

In 1348 the region of Gascony in France suffered badly from the plague. Sailors leaving the port brought with them not only the ship's cargo, but also the plague bacillus – *Yersinia pestis* – a disease from infected rats' fleas. The men would be sailing for days in cramped conditions, unwashed and malnourished. This provided the perfect conditions for infection and disease to thrive. It was in the same year that sailors came ashore in the port of Melcombe in Dorset, thus starting the spread of the disease. Dorset reaches to the Devon border, and so the plague was able to spread very quickly across the county. It continued to sweep the country for many years, diminishing and then returning, spreading fear and dread.

Many of the surrounding villages of Dartmouth suffered badly during outbreaks of plague infestation. In 1349, Capton, which lies approximately 5.5 miles from Dartmouth,

suffered badly from the Black Death. Dittisham, which lies a little further upriver, was also hit hard.

Due to the frequency of ships that docked at Dartmouth, laden with crew that were often suffering from infections and disease, deaths became a common occurrence. Priests were often called to give 'last rites' to the dying and because of their close attendance to those who were infected, they often became sufferers themselves. Although they were trying to help the dying, they may have been unknowingly passing on the disease to other uninfected townsfolk when attending them in their homes.

In the year 1627, the plague returned to Dartmouth once again. Fourteen soldiers died from the plague that year, and the families who accommodated them also became casualties of the same disease. Those who had succumbed to the plague had a letter 'P' placed by their name on the burial register. At this terrible time in Dartmouth's history, Andrew Voisey was the mayor. He had many unpleasant tasks to perform, one of which was to distribute shrouds where they were needed. The amount of cloth needed to make the shroud would depend on the size of the body to be wrapped – not a very pleasant chore to undertake.

Panic spread through the town as the disease took hold. Poor people who were suffering from the disease had nowhere to go, and so their houses were boarded up and they were left inside. Soon the plague was everywhere. The wealthy amongst them fled the town to

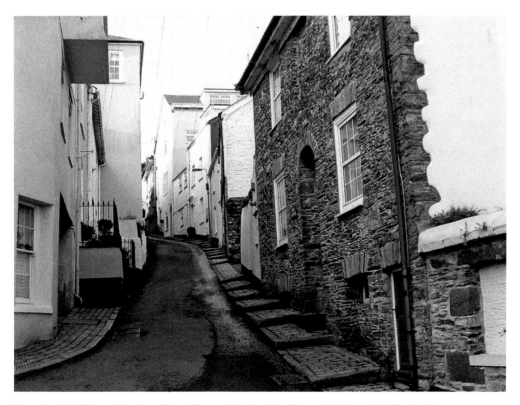

Crowther's Hill was the site of 'pest houses' during the plague. (B. Morris Collection)

escape the disease, leaving others to succumb to their fate. It was decided that two 'pest houses' should be built on Crowther's Hill and those who it was thought may have the disease were sent there.

The houses were made of timber and erected within a week, which came 'at a cost of £18 5s. 6d. In one, the lower pest house, Goodwife Franciss looked after twenty people, at £1s 6d each, while at the 'higher' one the Widow Cockwill looked after a further ten, the numbers diminishing as the people died'. 'Dogs and cats were believed to spread the infection and the order went out to kill every one of them. William Martin was paid 1s. to kill 40 dogs in one day' (Freeman, 1987).

One thing that they overlooked was that the disease was spread by rats and that dogs were their natural enemy, so in hindsight this was probably not such a good idea. There was another pest house erected in Townstal. In due course, with the infected being isolated in the pest houses, or boarded up in their own houses, the disease began to decline. During the outbreak a total of ninety lives were lost. Once the outbreak was under control, people who had lived in the countryside saw this as an opportunity to seek out work and began to move into the town, to start a new life.

An epidemic of cholera broke out across the country in the 1830s, which once again struck Dartmouth badly.

DID YOU KNOW?
In the year 1590, Miss Margery Wyche, of Dartmouth, died from bubonic plague. She was the first person to die of the plague, in the neighbouring town of Totnes, in that year.

Dartmouth During the War Years

For Dartmouth, the realisation of the war came on 1 August 1915. Four hundred and thirty-four cadets, of whom some were very young and not yet fully trained, boarded the waiting passenger ferry in Dartmouth, and crossed the Dart into Kingswear to catch trains to their new postings. Although probably putting on a brave face, what they really felt can only be guessed at, but apprehension and dread must have been part of it.

The next month, September, just weeks later, three ships were torpedoed by German submarines. These were the ships that some of these brave cadets had been posted to. In this first strike thirteen of the cadets from Dartmouth were killed and by the end of 1915 there were forty-one cadets killed from the original group.

1 September 1939 saw the start of the Second World War. During the years 1942 to 1944 operations originating from the River Dart to northern Normandy were carried out by the 15th Motor Gun Boat Flotilla. With the help of the French Resistance, they were able to return allied agents and injured airmen who had been shot down during operations over Europe. Many houses were used as naval headquarters, Agatha Christie's house Greenway being one of them. Lupton House, Churston, was another one. A great number of children

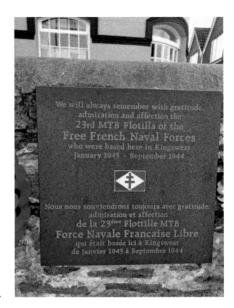

Wartime plaque, Kingswear.

were evacuated to the area, some of which stayed at Nethway House, Kingswear. Their mothers were to follow at a later date.

The Germans eventually took over most of France and also the Channel Islands, which are approximately 60 miles off the Devon coast. Both Kingswear and Dartmouth Castle batteries were prepared for battle and heavily fortified as well as having a boom placed between the two castles each night, which held a steel net. This was to give protection to local fishing vessels and other coastal crafts, and to protect the harbour from attacks from submarines and 'E' boats. This procedure was very reminiscent of the great chain which spanned the two castles in the Middle Ages.

Dartmouth was bombed more than once during the war. It was an important coaling station for all types of sailing craft, home of the Naval College and shipyards and so it was a prime target for enemy planes. On 18 September 1942, the Dart Valley fell under the shadow of six German bombers, which dropped bombs on the Noss Shipyard, coal bunkers that were moored on the river and the Britannia Royal Naval College. During this raid, twenty men lost their lives at the shipyard and also four coal bunkers. A wren also lost her life at the Naval College. She was Petty Officer Ellen Whittall, who was a telegraphist at the college and had just entered the ladies' restroom when the building was hit. Fortunately, much of the rest of the building was deserted at the time due to it being summer break.

In February 1943, three enemy planes again swooped down on the town and spread machine-gun fire and two bombs in their wake, one hitting Duke Street and the other Higher Street. During this raid fourteen people were killed and many buildings badly damaged, some beyond repair. The coastal forces had commandeered many buildings, one of them being the Royal Dart Hotel in Kingswear, which was known as HMS *Cicala*, for security reasons. This gave rise to a very strange broadcast from Lord Haw-Haw, in which he referred to it as having been 'sunk' – a prime example of war propaganda.

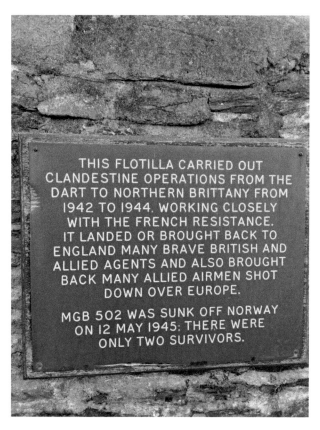

THIS FLOTILLA CARRIED OUT
CLANDESTINE OPERATIONS FROM THE
DART TO NORTHERN BRITTANY FROM
1942 TO 1944. WORKING CLOSELY
WITH THE FRENCH RESISTANCE.
IT LANDED OR BROUGHT BACK TO
ENGLAND MANY BRAVE BRITISH AND
ALLIED AGENTS AND ALSO BROUGHT
BACK MANY ALLIED AIRMEN SHOT
DOWN OVER EUROPE.

MGB 502 WAS SUNK OFF NORWAY
ON 12 MAY 1945: THERE WERE
ONLY TWO SURVIVORS.

Wartime plaque, Kingswear.

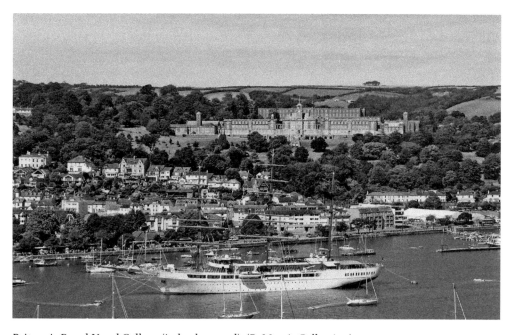

Britannia Royal Naval College (in background). (B. Morris Collection)

Another building used by the American servicemen was Lupton House, Churston, an old Georgian manor house once belonging to Lord Churston which lies just outside Brixham.

In April 1944 Exercise Tiger, also known as Operation Tiger, which was part of the rehearsals for the D-Day landings, was taking place at Slapton Sands, just a few miles up the coast from Dartmouth. This particular stretch of coastline bore a striking resemblance to the coast of Normandy.

Operation (or Exercise) Tiger lasted from 22nd to 30th of April 1944, and was one of many in the local area during the preparations for D-Day. The wholesale evacuation of part of the South Hams had been ordered to allow Slapton Sands to be used for top secret rehearsals of the intended Allied landings at "Utah Beach", Normandy. Tragically, around 1:30 on the morning of Friday April 28th, nine German torpedo boats in Start Bay attacked an Allied training convoy heading for Slapton – 749 US soldiers and sailors were killed or reported as missing in action. (Taylor, 2006)

Many years later, Ken Small, who was an expert on the incident at Slapton, found a Sherman tank under the water at Start Bay and after eventually obtaining permission from the American government, arranged for its salvage. It was raised from the seabed and placed on the car park opposite the shore.

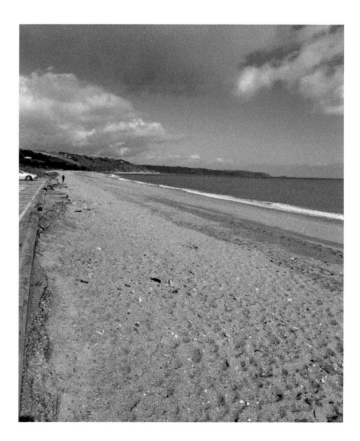

Slapton Sands, the site of
D-Day rehearsals.

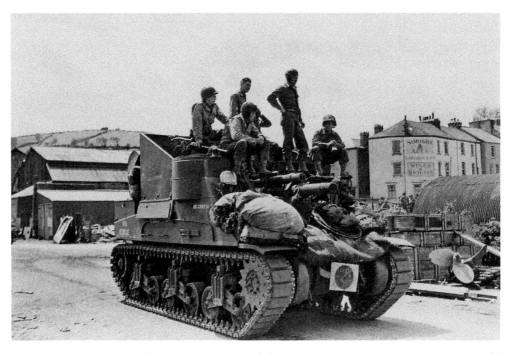

An American tank on the embankment at Dartmouth during D-Day preparations. (Totnes Image Bank)

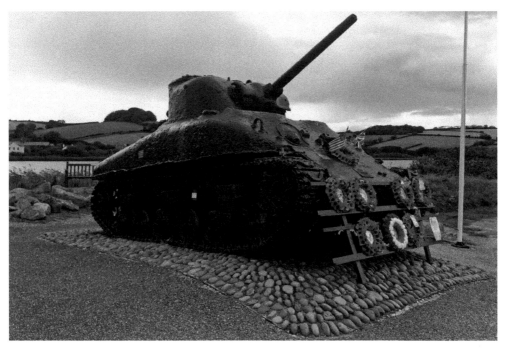

A Sherman tank recovered from the seabed in 1984 by Ken Small. The tank now stands as a memorial to all those who lost their lives during 'Exercise Tiger' and can be seen on the car park opposite the shore.

Heritage Steam Railway and Historic Ferries

Still in use today is the historic paddle Steamer *Kingswear Castle*. It runs daily sightseeing trips along the Dart and is the last remaining coal-fired paddle steamer operating in the UK. Built in 1924 at Philip and Son of Dartmouth, her engines date to 1904. She is owned by the Paddle Steamer Preservation Society, and in past times could carry approximately 500 passengers.

Although Dartmouth has a train station, a train never went to it but it did sell tickets. Tickets could be purchased which enabled passengers to board a ferry from Dartmouth and then sail across to Kingswear train station, on the other side of the river.

Today, access from Kingswear across the Dart to Dartmouth can be made via the Higher Ferry or the Lower Ferry. The Lower Ferry is the oldest ferry and became known as 'the horse boat' as it could carry a horse and cart. Originally powered by two men using long oars, by 1870 it was converted to steam power and was helped along by a tug which pushed the float. Today it is probably the only remaining tug-and-float ferry in the country.

The Higher Ferry had a very different type of power – two horses. Housed in a box in the middle of the floating bridge, the horses would walk around a capstan, which was situated horizontally in the floor of the box. This then enabled the bridge to be pulled across on chains. These poor horses must have spent their days following each other, going round and round in circles.

Today the ferry uses diesel-electric for power, but still uses the wire ropes for guidance.

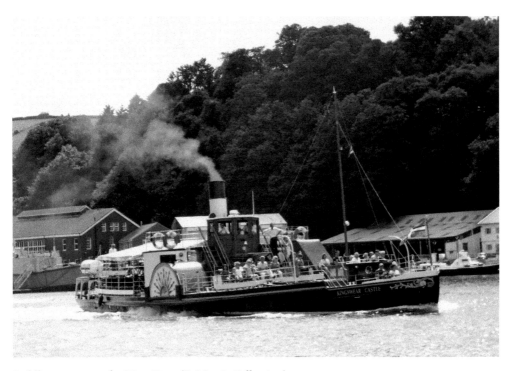

Paddle steamer on the River Dart. (B. Morris Collection)

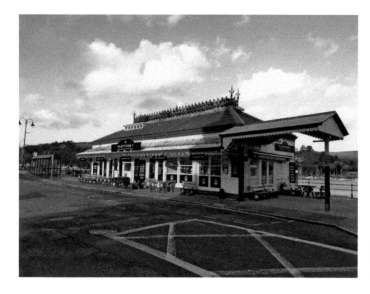

The Old Train Station, Dartmouth, which is now a restaurant.

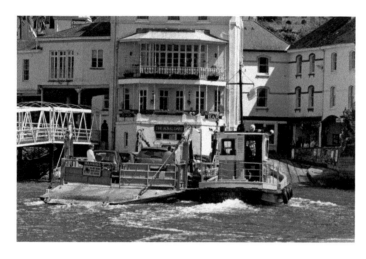

The last remaining 'tug-and-float ferry' in England. (B. Morris Collection)

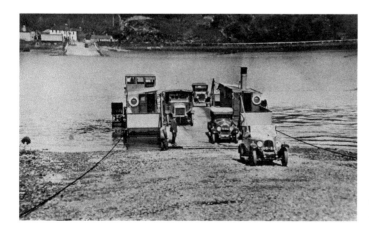

Old ferry. (Totnes Image Bank)

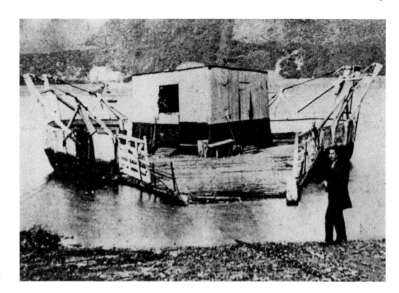

Old ferry.
(B. Morris Collection)

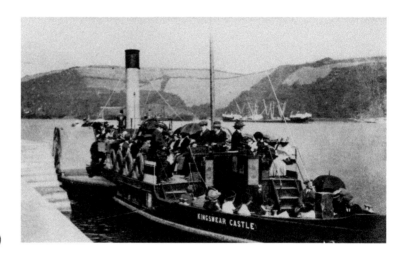

Old ferry.
(B. Morris Collection)

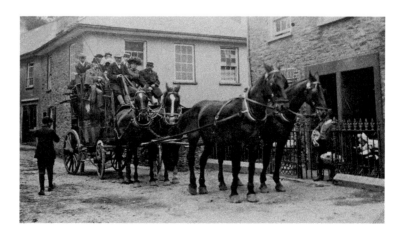

Coach, 1916. (Totnes
Image Bank)

DID YOU KNOW?
The Kingsbridge to Dartmouth horse-drawn coach would run between Dartmouth and Kingsbridge three times a day. This was a three-hour trip and a single fare in 1893 was three shillings. Foot warmers could be supplied if needed and this service ran until 1917, when the coach was replaced by a small motor coach.

The Dartmouth Steam Railway runs from Paignton to Kingswear. From Kingswear station the passengers then disembark and board the Dartmouth Passenger Ferry across the river to Dartmouth. It is a 6.7-mile (10.8-km) heritage railway, which opened on 14 March 1861, extending to Kingswear in 1864. The date 18 October 1877 saw the opening of a new halt, situated at the level crossing which led to the Dartmouth Higher Ferry. It was named Kingswear Crossing Halt and later became known as Britannia Halt. The Prince of Wales used this halt so that his sons could access HMS *Britannia*, moored on the river close by, which at that time was used as the naval training college, and dismantled many years later.

HMS *Britannia*, built in 1820, was of wood construction, with three decks, and had been in service in the Crimean War. It was used as an admiralty training ship for naval officers, along with the *Hindustan*, which was eventually taken to Plymouth.

The ships were anchored on the Dart around the years 1863–64 and attracted frequent visits from royalty because of the princes that came there for training. There was a rise in the population of the town as many of the staff, working on the vessels, made their home there. It brought a much-needed and welcome boost to the local economy. In 1902 Edward VII came to lay the foundation stone, which signalled the building of a land-based training college, the Royal Britannia Naval College. In 1916, HMS *Britannia* was scrapped.

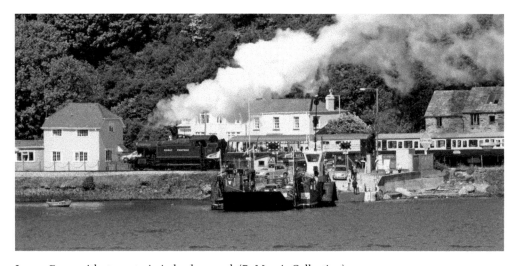

Lower Ferry with steam train in background. (B. Morris Collection)

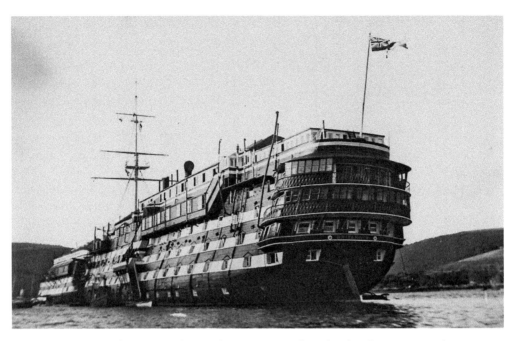

Britannia Royal Naval Training Ship. Cadets were trained on the ship from 1864 until 1905. From this time on they trained at the newly built college. (Totnes Image Bank)

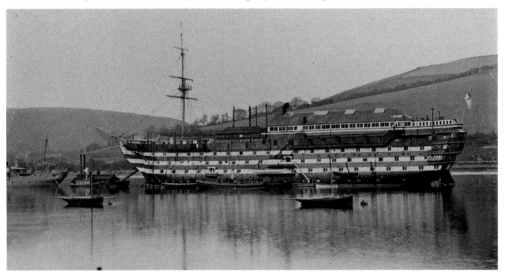

Hindustan, along with the *Britannia,* was used to train cadets. (Totnes Image Bank)

DID YOU KNOW?
During the fourteenth century Dartmouth was thought to be the fourth richest town in Devon, the other three towns being Plymouth, Exeter and Barnstaple.

2. Reclamation of Dartmouth from the River

One of the origins of the River Dart to the west is approximately 2-km north of Rough Tor, Yelverton, whilst to the east the source of the river can be found at Cranmere Pool, Okehampton. The place where both of the rivers meet is aptly called Dartmeet, which lies on Dartmoor. Fishing in the river is very good; when in season brown trout and sea trout can be caught, along with salmon. There is a depth of approximately 5 metres to the north of Dartmouth harbour, whilst in the fairway there is an excess of 10 metres, going up the fairway to Dittisham. It is thought that the name 'Dart' is Brythanic Celtic, meaning, 'river where oak trees grow'.

Dartmouth originates from three villages, Clifton, Dartmouth and Hardness, which became one borough. Two ridges lead down from Townstal Hill and it is at the bottom of these ridges that tiny fishing hamlets may have appeared during the eleventh century.

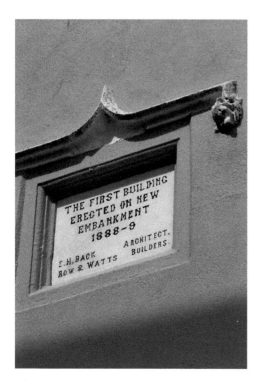 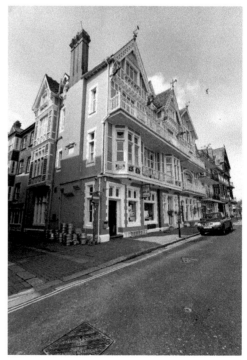

Above left: Plaque to commemorate the start of new buildings being erected on the 'new' embankment, 1888–89.

Above right: The first building on the 'new' embankment.

The first part of these ridges lay along the line of Church Road, Townstal Hill and Clarence Hill; the village at its foot, centered around Clarence Street and Broadstone, was called Hardness. The second ridge runs down Waterpool Lane and Crowther's Hill; this village was called Clifton-Dartmouth (to distinguish it from Clifton-Fleming, a hamlet of the neighbouring manor of Stoke Fleming. (Jaine, 1975)

It was from these tiny villages that Dartmouth began to develop. The area known as Hardness was the main shipbuilding area in the twelfth century and this continued up to the nineteenth century. The people who lived in this area at this time were mainly shipbuilders, and there were also many mariners and fishermen.

Land originating at the Quay and across to Royal Avenue Gardens is an area that was reclaimed from the river in the years 1588 to 1640 approximately. In those years the fishing trade was flourishing from Newfoundland. It was due to this that houses which stood at the far end in the nineteenth century were rebuilt. The houses which stand between the Castle Hotel (now the Royal Castle Hotel) and the Butterwalk are still mainly the same as they were in 1639.

The embankment, as it stood in 1885, did not allow for large ships to enter; the bridge only gave access to small crafts and so it is today that the boat float is only used by small

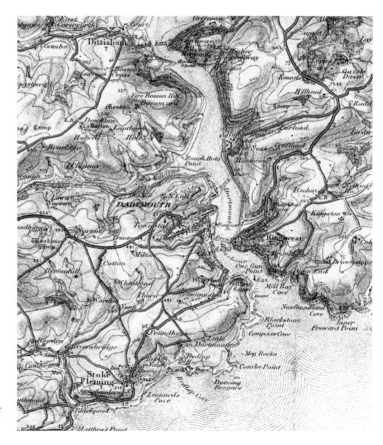

Ordnance Survey map of Dartmouth, 1911.

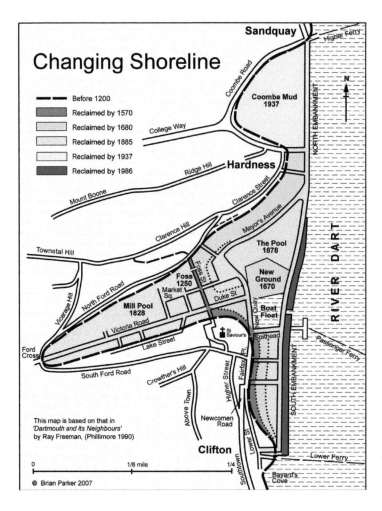

Map showing the changing shoreline. (By kind permission of Brian Parker)

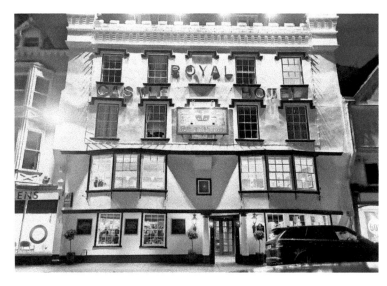

The Royal Castle Hotel, The Quay, Dartmouth.

boats. The area where the Royal Avenue Gardens now stand was reclaimed in the years between 1670 and 1680 from mudflats, providing mooring facilities along the walls where ships could moor up.

Opposite the car park, which is situated next to Royal Avenue Gardens, there was once two mill wheels that depended on the tides and were attached to the mill house. It was here that ships were built and also repaired. Some 50 yards behind Kings Quay is an area called Undercliff, also known as Silver Street, a narrow walkway that was the original 'red light' area of Dartmouth. The creek further up from Royal Avenue Gardens had been used for the seasoning of timber before it was reclaimed in 1930 to form Coronation Park, which took its name in celebration of the crowning of the monarch, King George VI, enabled by the building of the North embankment.

Where the old marketplace stands today is the original site of the tidal pool, which was damned along the Fosse, which is now known as Foss Street. The movement of the water powered the corn mills. For centuries, the washing and drying of linen took place higher up at Ford where a small weir held a pond of fresh water.

For many years, the only water supply to Dartmouth came from streams which ran down the hillside, and from an aqueduct and conduit. In 1908, the people of the town welcomed the opening of the Old Mill Creek Water Works, which in 1926 was further extended.

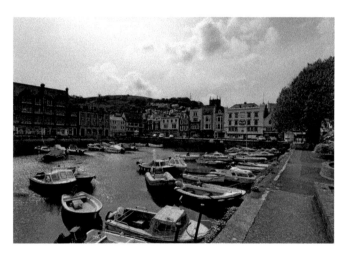

Above left: The Boat Float, Dartmouth.

Above right: Foss Street, originally a dam across a creek.

3. Architecture and Buildings of Interest

There are many different examples of architecture in Dartmouth, both old and new. Many are influenced by the wealth acquired by Sir Humphrey Gilbert (half-brother to Sir Walter Raleigh) and other wealthy merchants of that time. Gilbert sailed to Newfoundland and secured it for the Crown, thus initiating the development of the Newfoundland Banks Fisheries.

The Butterwalk

One of the main attractions is the Butterwalk. It is a Tudor building with a beautifully carved wooden facia supported by granite columns, built between 1635 and 1640 by Mark Hawkins. Built on reclaimed land, the foundations became insecure and over time the rear of the building began to subside. It is a Grade I listed building, originally consisting of a row of four merchants' houses which now comprises of shops and the Dartmouth museum.

It was damaged by a bomb blast in 1943 and received major renovations in the 1950s. At one point it was in such a bad condition that it was thought that the best option might be to demolish it, but such were the protests of the townsfolk that it was reconstructed. Even the original plasterwork, which had detached itself, was pieced together and replaced.

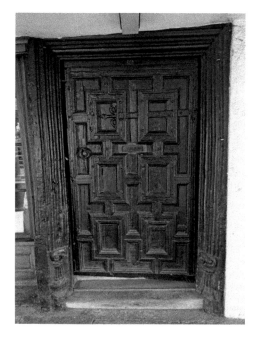

An old doorway on the Butterwalk.

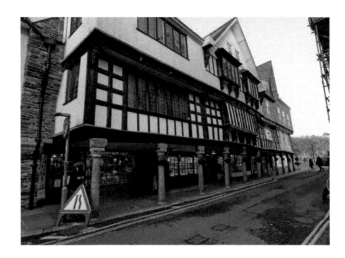

The ancient Butterwalk,
Duke Street.

No. 16 Clarence Hill

One of the narrowest houses in England is at No. 16 Clarence Hill. It has a fascinating
aspect being only 8 feet wide, nestled between two other properties. It was originally used
as an entrance to Mount Galpine House, which was the home of an old Dartmouth family,
the Holdsworths. Beautiful carvings can be seen on the facade, which dates back to 1629.
These were recovered from a merchant's house which had been damaged during the war
and are now part of the front of the house.

No. 16 Clarence Hill, one of the narrowest
houses in England.

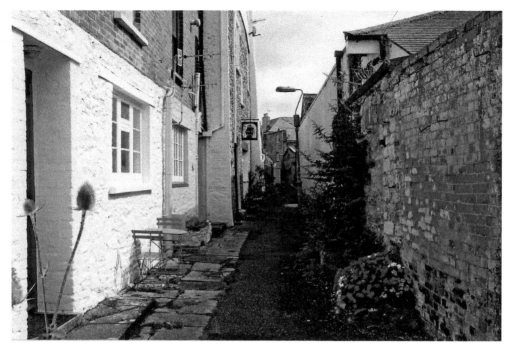

Undercliffe originally backed onto the boatyards before reclamation of the land from the river. (B. Morris Collection)

Undercliffe (Silver Street)

Undercliffe, also known as Silver Street, is a narrow alleyway which is now fronted by Mayors Avenue, but originally lay behind the shipyards. In the early twentieth century it was a run-down, notorious slum and a known 'red light' area. A Dr Mivart, who was from the Local Government Board, was sent to inspect the sanitary conditions of the town. Whilst inspecting a property in Silver Street, he found 'an enormous collection of foul rags in a central room having no light or ventilation. A portion of the living room in this place was boarded off to contain a hopper W.C with flushing apparatus broken; The pan broken and plugged with rags.' He went on to say 'There were layers of filthy wallpaper harbouring bugs' (Freeman, 1987).

It is said that when the policeman went to do his rounds, he always took another policeman with him to walk down Undercliffe, such was its bad reputation. Today, it is a very different place, with private residences and colourful facades.

Higher Street

Although there were many beautiful houses in town, owned by wealthy merchants, there was also much poverty and hardship. Tenements in Higher Street were demolished in 1925, many people living in cramped, overcrowded conditions. Some houses were occupied by as many as fifteen families in one house, all sharing one closet and water tap. Large families were also living in three-bedroomed cottages, situated behind the embankment. These were demolished in the 1930s.

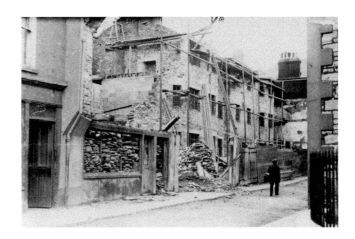

Higher Street tenements being demolished in 1925. (Totnes Image Bank)

The Shell House, Lake Street

The Shell House, No. 47 Lake Street, was originally an old fisherman's cottage, until a collection of antique shells, bought from an auction, completely changed it. The outside of the property became decorated with 'millions' of seashells and crustacean shells, and the beautiful seascape continued inside the property. Even the bathroom became a mermaids' grotto. This was around thirty years ago, and the shapes of anchors, boats and beautiful nautical designs can still be seen today, adorning the outer walls of the property. The shellscape cannot be seen inside the property, but some of them are still there and are protected behind panels. The property is let out for holiday rentals and is central to the town. It is part of Dartmouth's history and many Dartmothians remember passing it over the years and marvelling at its beautiful, unusual art.

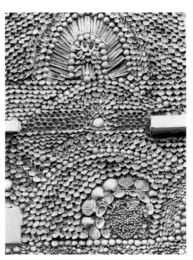

Above left: The Shell House, Lake Street.

Above right: Details of shells on the Shell House exterior wall.

The Old Market

In 1231, enabled by a royal grant, one of the first markets in Dartmouth was held in open stalls on the Quay. In later times, the market was moved to the old market square. Dating back to 1828, the market then was a pannier market, where ponies carried goods on their backs every day in baskets (panniers), full of fresh farm produce. The area where the market was built was originally part of the old mill pool, which was to the west of Foss Street. When the land was reclaimed it enabled the farmers access with their wagons to provide the produce for the local townspeople.

After the First World War, the townspeople were finding it very hard; money was scarce and so was employment. A local charitable committee provided soup and stew twice a week to the needy, for a half-penny, in the soup kitchen. For many years the townspeople suffered hardship and in 1932 the soup kitchen became very busy once again, dishing out between sixty to seventy gallons of soup per week, at a penny a pint, with up to 400 children dependant on it.

Various notices, dating back to 1885, can still be seen on the walls of the market. One such sign reads *'Blondett's Christmas Gift',* which dates back to 1885, telling of the charitable gift he bequeathed to the poor of the town.

Henry Blondett was a retired publican who had been the landlord of two pubs in the town and he wanted to give something to the poor of the town and so left an annuity with dividends, to be shared amongst them each year.

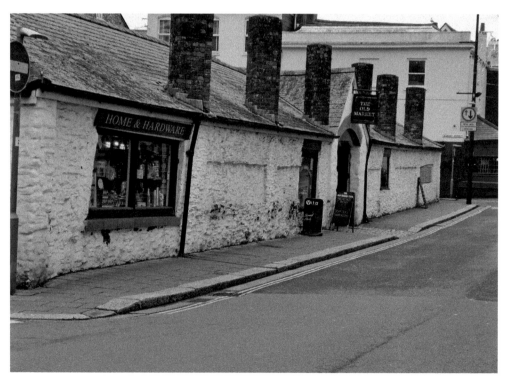

Entrance to the old market, Victoria Road.

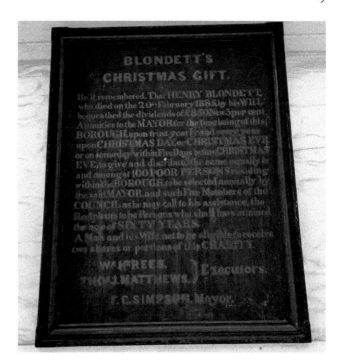

Plaque on old market wall: 'Blondett's Christmas Gift'.

A cosy corner in the old Market Square.

Another sign reads, 'CAUTION: Notice is hereby given that the Mayor, Council and Burgess of Dartmouth have determined that no horse, mule, or ass, shall be permitted to remain in any street, lane, market-place, alley, or slip, within this borough, unnecessarily, and to the annoyance to the public, and that in-case such shall hereafter be found so trespassing, the same impounded, and the owner hereof prosecuted to the severest extremity of the law, September 1839. By order of the council: Daniel Codner Esq. Mayor.'

Today, it is a lively and vibrant place, with tempting cafes, fresh produce, along with bric-a-brac stalls and artisan goods. It is also where the offices of *The Dartmouth Chronicle* can be found.

Dartmouth Museum

Dartmouth Museum is a Grade I listed building and today it is situated on the Butterwalk. It is a very popular tourist attraction with many exhibits and interesting information. In 1927 it was housed in the Ancient Workshop in Anzac Street, which was also William Henley's workshop. William Cumming Henley (1860–1919) was a historian, writer, microscopist and an early scientist. After his death his sister organised an exhibition of his works in his little museum in Anzac Street and from 1 June 1927 until September 1928, approximately 4,000 people went to see it. He also had a great sense of humour, and was capable of writing some very witty prose.

King Charles II visited Dartmouth in 1671. He was travelling from Portsmouth to Plymouth in his newly fitted yacht *Cleveland* and was caught up in strong winds from Lyme Regis which caused him to turn back to the safety of Dartmouth harbour. He was then taken to the Butterwalk, and he was entertained in the house which belonged to a rich merchant and which was thought to be the best in which to entertain the King. These are the same rooms that today house the museum.

Entrance to the
Dartmouth Museum.

Nethway House, Kingswear

Later that day the King crossed the river to spend the night at Nethway House, Kingswear. Nethway House is what is known as a 'calendar house' – a house that architecturally symbolises the months, days, weeks and seasons in a year. It has four chimneys, which represent the four seasons; twelve bedrooms, which represent the months of the year; fifty-two windows, for the weeks in a year; and possibly the panes of glass may amount to the days in a year.

The theme for this type of house dates back to the Elizabethan era when it was the fashion amongst the gentry to showcase any advance made in science and especially mathematics in as unique a way as was possible. This is how the idea of building a house which encompassed the components of a year became popular, although there weren't many of these houses built. Another interesting item is a plaque which can be found on one of the trees in the garden area. It reads, 'Planted by HRH Prince George, November 2nd 1878'.

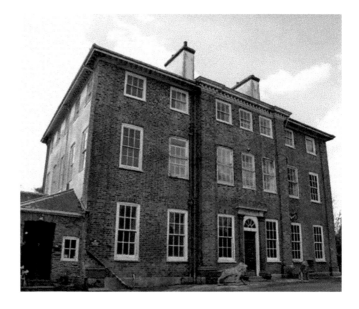

Nethway House, Kingswear.

Plaque on tree in the garden of Nethway House.

The Pillory, Stocks and Ducking Stool

The pillory and stocks (medieval AD 1066 to AD 1539) were situated in a small square where Higher Street and Smith Street meet. This was the centre of Dartmouth in medieval times. Unfortunately, today there is very little to be seen of them. In the late 1800s, the water used to come up to the north-east corner of St Saviour's churchyard. It was here that 'wives with nagging tongues' were subjected to a ducking in the 'ducking stool', or 'cucking stool' as it was also known. It was also used as a punishment for tradesmen who sold goods that were not up to standard, or of a short weight.

The oldest recorded street in Dartmouth is called Smith Street, possibly named after a goldsmith. The oldest pub is The Seven Stars, although The Cherub is sometimes thought to be the oldest. The Cherub was once a merchants' house and then became a shop, whereas, The Seven Stars has always been a pub.

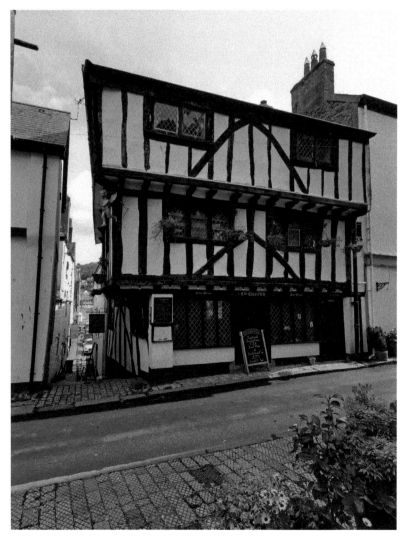

The Cherub,
Higher Street.

Above left and right: Coats of arms above Kendricks shop.

Coats of Arms above Kendricks

In Lower street you will find a red-fronted shop called Kendricks. Above the Tudor-style shop there are various coats of arms of past patrons of the town. Some are merchants of the town whilst others are famous mariners. Names such as Raleigh, Drake, Gilbert, Newcomen, Hawley and so on, are all depicted on the very colourful shields.

The Harbour Bookshop

The Harbour Bookshop, Dartmouth (founded in 1950s) closed in 2011. The name of the proprietor of the bookshop was well known worldwide – Christopher Robin Milne. He was the only child of the celebrated author A. A. Milne, and whilst a child he was the inspiration for the character Christopher Robin who featured in his father's *Winnie the Pooh* stories. Today, the Community Bookshop in Higher Street carries on the well-loved theme, and sells *Winnie the Pooh* books and cards, and even some collectors' items.

St Petrox Church

The Church of St Petrox lies to the south of the town and is one of three ancient churches in Dartmouth. Deeds relating to 'Little Dartmouth', dating back to 1192, are possibly where we find the first mention of this religious building. The church lies adjacent to the castle and is a Grade I listed building, and was practically rebuilt around 1641. The church accommodates for the south of Bayard's Cove and is quite a walk, even from that point. Over the years many would have walked along the trackway up to the church. Today, it is easily accessible by car. It may have originally been a primitive chapel with a holy well,

Community Bookshop, Higher Street.

which came to be known as the Monastery of St Peter, also perhaps providing a guiding light for boats entering the River Dart. It is a particularly romantic and beautiful setting for weddings for the residents of Dartmouth and is a very popular place of worship and a tourist attraction.

Whilst on a recent visit to the church, I noticed in the church guidebook an interesting piece of history:

> The 20ft spire of the church was removed in 1856 because it blocked the view of the town for the lookout stationed at the Castle whose job it was to communicate the names and details of the ships navigating into the River Dart from the sea. (A Guide to St Petrox Church, Dartmouth)

On the floor of the central aisle is a memorial stone to Mary, the wife of John Hodge, who died on 7th day of August, aged forty-five years, dated 1692. Below the inscription is a primitively drawn skull and crossbones with an hourglass which looks as though it has wings either side of it. The skull and crossbones are symbolic of death. The hourglass is thought to mean that 'time is passing by or passes by very quickly' and what may be wings to the sides of the hourglass are sometimes taken to mean that 'time flies by'.

On the south wall, a funeral hatchment can be seen. This is the diamond-shaped board with skulls painted on the corners of it, along with some bones. Central to the board would be the family coat of arms of the deceased. This hatchment would be carried at the front of the funeral cortege and after the procession it would be hung outside the family home, and then to be hung in the church at a later date.

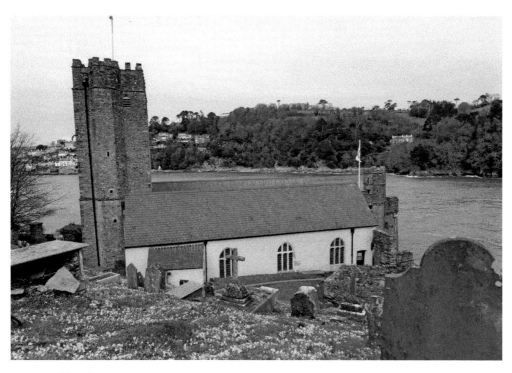

St Petrox Church.

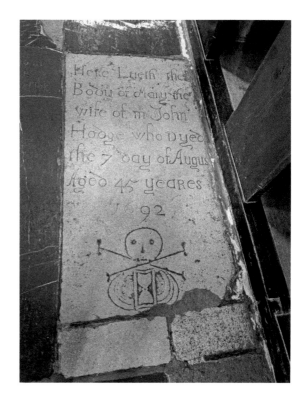

Gravestone of Mary Hodge, with skull and crossbones detail.

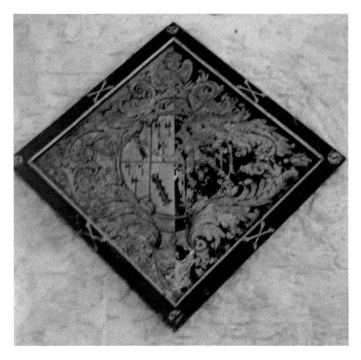

Funeral hatchment with skull and crossbones detail along the borders.

There is so much history attached to St Petrox that it is well worth spending some time there to look around. It has a beautiful and peaceful atmosphere.

St Clement's Church, Townstal

This was always thought of as the mother church of Dartmouth, as it was to this church that the congregation made their way across a ford and up the hill which is approximately 350 feet above the height of the River Dart. It is dedicated to the memory of St Clement, who was an early bishop of Rome and who was martyred by drowning. He was weighted down with an anchor to make sure the deed was carried out.

The church was granted to Torre Abbey in around 1198. The vicar allegedly drowned himself due to all the unrest within the town concerning the church. (Strange he should choose to this way to commit suicide; was he perhaps influenced by St Clement's martyrdom?) It was because of the vicar's suicide that the Bishop of Exeter took it upon himself to forbid any religious services as a type of punishment. This lasted for two years. A wealthy burgess of the town was granted permission to hold private services in his house, but for the other folk, less wealthy in the town, there were none.

The church has many interesting additions. Among the roof bosses can be see three different interpretations of the 'Green Man'. The Green Man can be found carved into the wood and sometimes stone of many medieval churches and is often seen as a symbol of rebirth and resurrection. There are also three masons' signs within the church. These were often left by masons as a type of signature for their work. In the area of the naive is the face of a mason, whilst on the floor, carved into the floor stones, are more masons' marks.

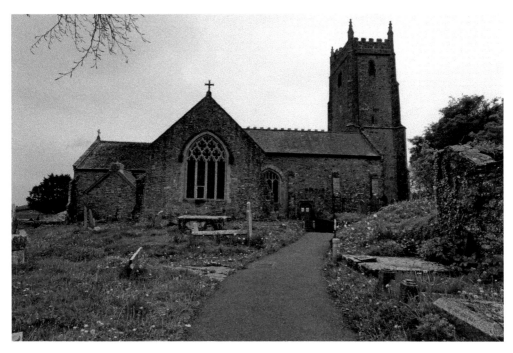

St Clement's Church, Townstal.

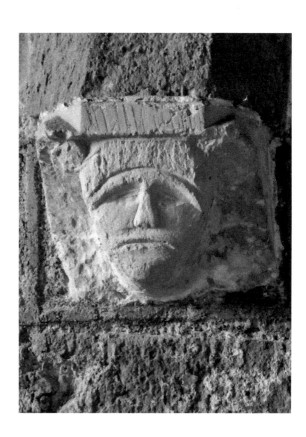

Mason's face seen on stonework
inside the church.

As you leave by the north door, there is a grave marked with the Star of David, recording the death of Thomas Morgan who in 1855 died at the age of just twelve months. There is also a monument to the Seale family. The monument comprises of a pyramid and it has been said that there may be a secret entrance concealed within, which leads from the church, but this is thought to be just a myth.

Near to the porch lies another unusual monument. It is disc shaped with eight symmetrically placed holes, the symbolism of which is unknown. There are also several war graves and also the grave of a soul drowned at sea in recent years; it refers to Melanie as 'a sparkling light extinguished by the sea'.

Outside the South door there is a mound in which the grave of Sven Somme had been previously laid to rest. In recent years, at the family's request, it has been moved to Bovey Tracey, to be with other family members. Dispensation had to be granted from on high for this to be done. Born in 1904, he was a Norwegian zoologist and ichthyologist and whilst Norway was under German occupation in the Second World War, he was active in the clandestine intelligence organisation known as XU (X meaning 'unknown' and U meaning 'undercover agent'). He was sent on an operation to photograph submarines and equipment near a torpedo base. Whilst taking the photographs, a ray of light flashed off his camera lens and he was discovered. He was taken prisoner, but managed to get away, thus initiating a 200-mile escape across the hazardous mountains between Isfjorden and Eikesdalen. He was chased by German soldiers with bloodhounds through the treacherous mountains. In order not to leave telltale tracks, he occasionally leaped from tree to tree and managed to escape, eventually making his way to England. Whilst living in England he met his future wife, Primrose, and eventually became father to three children.

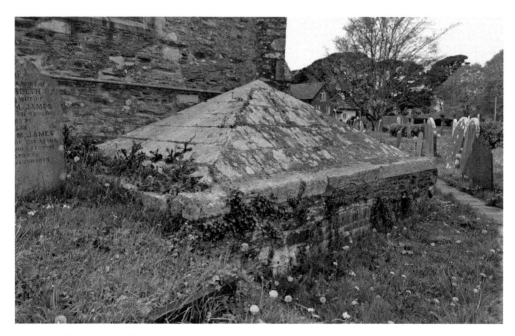

The Seale family mausoleum.

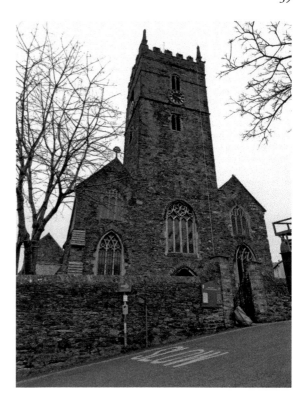

St Saviour's Church, Anzac Street.

St Saviour's Church, Anzac Street

In 1286 Edward l granted permission to build a church near to the river after he had come to inspect the harbour, which he intended to use in his French campaigns. Unfortunately, he did not consult the Bishop of Exeter or the Abbot of Torre Abbey and they were greatly angered as it was they who appointed the priests and oversaw the daily running of the church. Their objections were heard for a long time but eventually Bishop Brantingham of Exeter agreed to consecrate the church, and it was called Holy Trinity, although in 1430 it became known as St Saviour's. The building of this church was of great relief to the people of Dartmouth as it meant that they no longer had to walk up the great hill to St Clement's, Townstal, although St Clement's remained popular for the people who lived closer to it. St Saviour's was the church favoured by the rich merchants of the time and much money was lavished on it.

The chancel was built by Hawley, and his tomb can be found there. There is a brass monument set in the floor, which is covered over with a carpet to protect it. The brass depicts Hawley and his two wives. His first wife, Joanna, died in 1394 and was subsequently buried in the chancel. His second wife, Alicia, came from a very prosperous Cornish family of Tresilian and died in 1403. If you look carefully at the brass you can see that each of the wives' hair is adorned with jewels and also that there are a pair of small dogs which have bells on their collars at each of the wives' feet.

These are by no means the only churches in the town. There are others which also have an interesting history and faithful congregation.

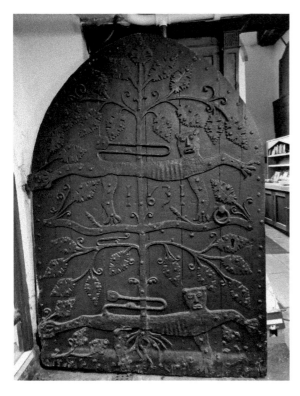

Medieval door. The South Door has been carbon dated to 1361 although the door carries the date 1631, which is the date that the door had repairs carried out. It is furnished with medieval ironwork, and also shows the 'Tree of Life' and a pair of leopards, often seen as a Plantagenet symbol.

The Green Man, St Saviour's Church, carved into the beautiful screen, an early pagan symbol.

The fifteenth-century pulpit, made of stone and ornately painted.

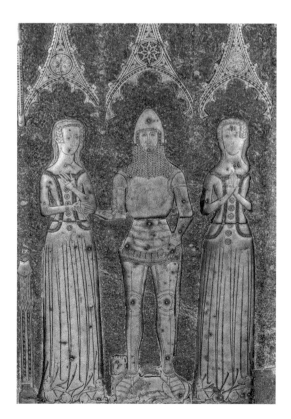

The Hawley Brass *c.* 1480, St Saviour's Church. (© Parish of Dartmouth PCC)

Castles and Forts

On arriving at Dartmouth Castle you will notice a car park to the right-hand side as you approach it. Above the car park you can see the ruins of the original 'Fortalice', a fourteenth-century castle. It was here that catapults and possibly a cannon were placed to fend off the threat of an attack from the sea.

Opposite the ruins now stands the ticket office for the castle, which was once a Second World War gun-shelter. This is part of the Old Battery, which has seen continuous development from the sixteenth century up to the twentieth century, and lies beneath and to the front of the gun-shelter.

Work on the main castle began in 1388, and was later further fortified with a gun tower. The castle was built during the wars with France because of the danger of attacks coming across the Channel. On completion of the castle a huge chain, which could be moved, was connected from the castle, across the river to the fort on the Kingswear side.

The chain spanned a distance of 250 metres across the opening of the Dart Estuary, from Godmerock, which is situated on the eastern bank, across to Dartmouth Castle, which lies on the western side. It is thought that the chain may have first appeared in the 1480s. By raising the chain enemy ships could be stopped in mid-river, which would then render them an easy target for gunfire.

The castle is now owned by English Heritage and in recent years they commissioned an expert in the field of historical engineering to try to investigate how the chain might have worked, as it was thought that the chain would have been much too heavy for a winding mechanism. After much research they came to the conclusion that it may have been with the help of the boats. This could have been achieved by the boats spacing themselves out evenly across the river and by some means each boat lifting the chain from the water, thus helping to maintain enough tension in the chain to block any ship trying to pass it.

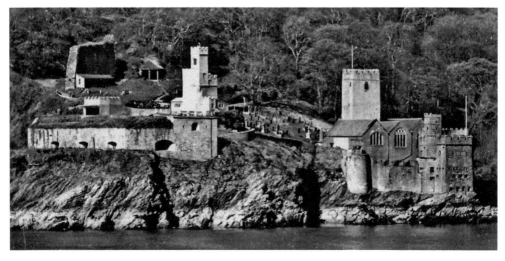

Photo showing original 'fortalice' (1388) to the left of the background, the castle predecessor, with gun battery in the left foreground; St Petrox Church is to the right, with the parts of Dartmouth Castle beneath it. (B. Morris Collection)

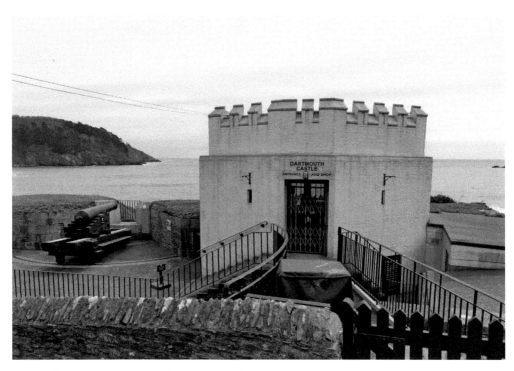

Gun shelter, now used as the ticket office for the castle.

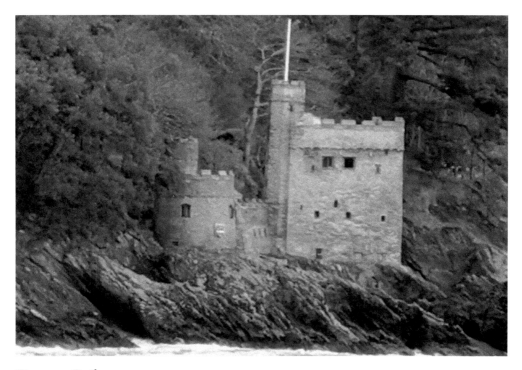

Kingswear Castle.

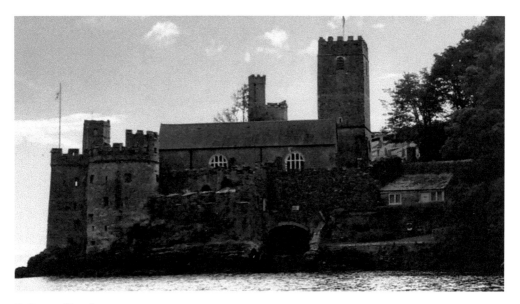

St Petrox Church.

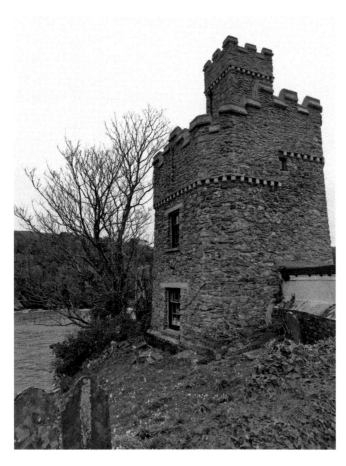

The Square Tower.

Back in the town, just a short walk along Bayard's Cove is Bayard's Cove Fort. It is stood upon a sixteenth-century stone quay, at the water's edge, and is believed to have been built around 1509–10, and is definitely known to have existed there by 1537. At the end of Bayard's Cove, is Bearscove Fort. This would have been a second line of defence if the other two castles had been breached at the mouth of the river. It was built in 1539 for use as a coastal defence on Henry VIII's command.

DID YOU KNOW?
Bayard's Cove later came to have the name of Monkey Town – thanks to the nickname of the sailors who clambered over the rigging and looked after the cannon powder of the ships docked there. Strictly a

Monkey' could be used to refer to anything of small size on board a ship, but it was used around many ports to refer to sailors themselves. It was a name which carried with it a warning – after months at sea trouble could brew around the 'Monkeys' when they made port. (*By The Dart*, 2011)

Bayard's Fort.

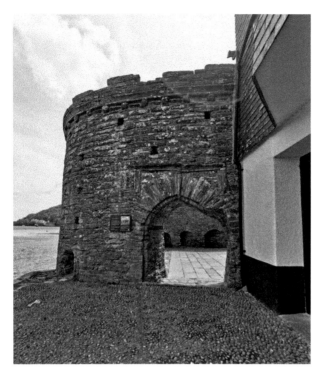

Bayard's Fort.

Although the castles were heavily fortified, the people of Dartmouth were very wary of seaward attack and so the fort was seen as a back-up if the castle's defences should fail.

Whilst most of the attention was set on the sea and the dangers that swept in with each tide, the town was caught off guard by an attack, not from the sea, but from the land. This happened many years after the fort was built, during the English Civil War. In 1643 Dartmouth was under siege from a Royalist force, headed by Prince Maurice, who was Charles I's nephew. The siege lasted for around a month.

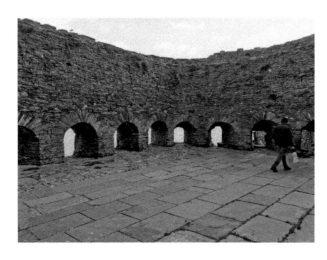

Bayard's Fort.

From this time on and into the eighteenth century, Dartmouth went into decline and some areas of the town became slums. There was much overcrowding and neglect, fuelled by poverty.

For a short while, around 1940, the fort came back into use again as a machine-gun post. Unfortunately, this was to be short-lived as the gun-ports gave too much of a restricted line of fire. After this time, the fort came under the care of English Heritage.

DID YOU KNOW?
Since 1998, the Britannia Royal Naval College at Dartmouth has been the only establishment that trains officers for the British Royal Navy. Apart from its austere history, it also played its part in a royal romance. It is where the Queen and Prince Philip had their first publicised meeting. At that time Elizabeth was just thirteen and Philip was eighteen, but even though still very young, this may have sparked a blossoming romance.

The Wishing Well, Kingswear

The wishing well, which is situated opposite the Kingswear train station, had been fashioned from a horse's drinking trough by the late Colonel Toms, to celebrate his twenty-fifth anniversary. Over the years many people have thrown coins into the well and made a wish; how many of those came true, we will never know.

The Wishing Well, Kingswear.

4. Notable Dartmothians

Dartmouth has been the birthplace and home to many notable people: famous writers, inventors, even a mayor who became a pirate. One of Dartmouth's most famous residents was Agatha Christie, who lived at Greenway, which overlooks the River Dart.

Agatha Christie

Agatha Christie married twice, and it was with her second husband, Max Mallowan, that she purchased Greenway as a holiday home and lived there from 1938 to 1959. It was a home they both loved very much with beautiful gardens that stretched down to the river. She once described Greenway as 'the loveliest place in the world'. Agatha was a very prolific writer, and among her many characters was Hercule Poirot and Miss Marple. It was whilst she was staying in The Royal Castle Hotel, Dartmouth, that she wrote *Ordeal by Innocence*, later made into a film in 1984. Greenway is a beautiful Georgian mansion which is now owned by the National Trust and is a very popular tourist destination. An earlier building was home to Sir Humphrey Gilbert and his half-brother, Sir Walter Raleigh.

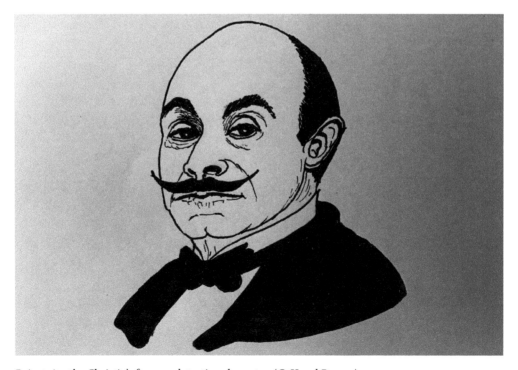

Poirot, Agatha Christie's famous detective character. (© Hazel Brown)

Rachel Kempson

Rachel Kempson (Lady Redgrave) was born in Dartmouth. The family home was in the grounds of the Britannia Royal Naval College. As a young girl she was sent away to a convent school in Sussex, but on school holidays she would return to her home in Dartmouth and spend many happy hours inventing plays and acting, going on to train at RADA and eventually becoming an accomplished actress in her own right. She later married actor Michael Redgrave and went on to have three children: Vanessa, Corin and Lynn.

Flora Thompson

Flora Thompson lived in an area known as 'Above Town' between 1928 and 1940. She was an accomplished writer and during these years she wrote the books *Lark Rise* and *Over to Candleford*. In 1943 she wrote *Candleford Green*, which incorporated the two earlier books and became the television drama known as *Lark Rise to Candleford*, which aired for four seasons.

Robert Graves

Robert von Ranke Graves (1895–1985) was an acclaimed war poet and author. During his time as a soldier in the First World War he was badly wounded by a fragment of shell which penetrated his right lung leaving him seriously injured. He received treatment in the field, but he was so badly injured that he was thought to be dead. His family were informed and an obituary went into the newspaper. You can imagine how surprised he was when he read about his own demise in the tabloid.

After making a recovery, some years later he went on to write *I, Claudius* and in 1948 wrote the highly acclaimed work *White Goddess*. Between the years 1940 and 1946 he was living at Vale House, which is on Greenway Road, just upstream from the River Dart.

George Parker Bidder

George Parker Bidder (1805–78), also known as the Calculating Boy, began to take a great interest in numbers as a young child and would use his playthings to represent mathematic challenges. He had an older brother who saw that George had an interest in numbers and taught him to count to one hundred. Once he had grasped this knowledge, he went on to eventually deal with and solve the most intricate of arithmetical puzzles. He had a brain which worked like a modern-day computer and this attracted a lot of attention. His father was very proud of him and took him to many places around the country to exhibit his mental ability. In later years he became a distinguished engineer and his knowledge of railway construction led him to work alongside Robert Stephenson.

His son George Parker Bidder Jr inherited much of his father's calculating genius and went on to become a barrister. His second son, George Bidder III, became a marine biologist. In 1906 he threw a bottle containing a message into the sea as part of his research into currents – one of thirty. In 2015 the bottle washed ashore on one of Germany's North Frisian Islands and was found by a woman on holiday on Amrun, one of the islands. Inside the bottle was a postcard asking that, if found, please post back to the Marine Biological Association in Plymouth, Devon. The woman did not realise how old the bottle was and posted the card she found inside the bottle back as instructed. Bidder had died at the age of ninety-one in 1954 but the association still exists. The reason he had sent out messages in bottles was to prove that the current in the North Sea did in fact flow from east to west. Many of the other bottles were found by fishermen. The bottle is currently the oldest message in a bottle to be found and may warrant a place in the *Guinness Book of Records*.

In the east window of St Petrox Church is a memorial in memory of Bidder which was donated by his daughter, Bertha. The window shows the figures of four saints – St Peter, St George, St Petroc and St Paul – and beneath it you will find the Bidder Memorial inscription.

Mary Nightingale

Mary Nightingale has a family home in Dartmouth. She is known to many as a newsreader for ITN on ITV news and became Dartmouth Caring's new patron in 2016.

Thomas Newcomen

Thomas Newcomen (1664–1729), born in Dartmouth, was the inventor of the atmospheric steam engine, an example of which can be seen in the Dartmouth Visitors Centre and is the world's oldest preserved working model.

He was an ironmonger by trade, and invented the first fuel-burning engine in 1712. His steam engine was very useful for draining the water from mines; at that time the water had to be either pumped out manually or horses had to haul buckets of water up from the mine, which was a lengthy and slow process. The engine was able to pump water by condensing steam, which created a vacuum, thus powering the pump. Eventually around 100 of these engines were used in Britain and across Europe.

The Royal Mail released a stamp on 23 February 2012 which features Newcomen's atmospheric steam engine. It was part of the 'Britons of Distinction' series. A fitting tribute to the ingenious inventor.

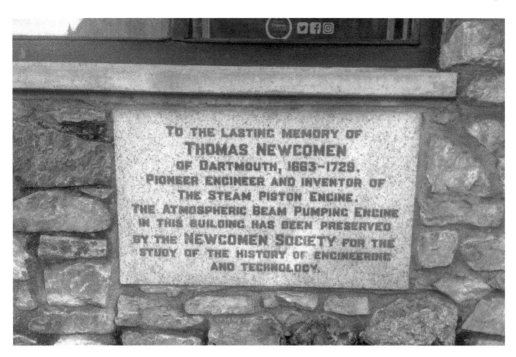

Plaque dedicated to Thomas Newcomen.

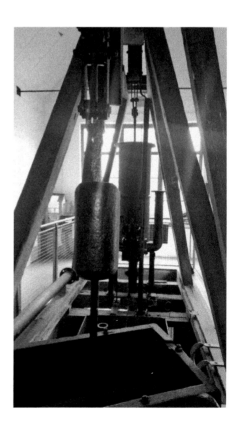

Working life-size model of the Newcomen atmospheric steam engine. (© Dartmouth Visitors Centre)

Dartmouth Tourist Information Centre, Mayor's Avenue.

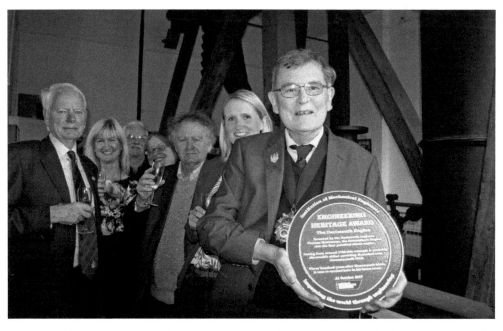

Dartmouth Tourist Information Centre being presented with a prestigious heritage award from the Institution of Mechanical Engineers in 2017. (© Dartmouth Visitors Centre)

Willian Veale

William Veale (1791–1867), the 'Robinson Crusoe of Dartmouth', was born in Dartmouth and had a love of the sea. He started as an apprentice at a very early age and eventually became a fully qualified captain. He went on to command the *Princess of Wales*, taking on a crew of fourteen men, and set sail for the islands south of Africa where he was to pick up a cargo of seal skins. Whilst on this voyage the ship encountered a terrible storm which wrecked the ship, leaving Veale and his men at the mercy of the elements. Luckily all fifteen aboard the ship managed to make shore on an uninhabited island. For the next two years they lived on the island in a Robinson Crusoe-like existence, before being rescued.

DID YOU KNOW?
Daniel Defoe, the author of *Robinson Crusoe*, came to visit Dartmouth in the 1700s.

John Hawley

John Hawley, sometimes spelt Hauley (born around 1340–1408), was elected mayor of Dartmouth fourteen times and served as the town's Member of Parliament twice. He was a very wealthy man and also a very skilful mariner. During his time there would not have been a navy, but it was not unknown for the King to enlist the help of the owners of certain merchant ships to go to sea and attack ships that would be seen as the King's enemy. The spoils of the captured ship and cargo would be shared, firstly with the King and then the owner of the ship and his crew. Hawley became well known for his exploits at sea, not always just attacking enemies of the King but occasionally innocent ones that may be lucrative.

In 1373 Chaucer visited Dartmouth and it is thought that during that visit he may have met Hawley. This may have led Chaucer to use Hawley as his role model for the colourful character he later wrote about in Canterbury Tales, a 'Shipman of Dartmouth'. In his tale the shipman was a very skilled sailor, but had a darker side, that of a pirate.

John Hawley was a man of great means who owned forty-five houses about the town. He amassed a great wealth which enabled him, through commercial ventures, and various legendary 'ventures' at sea, to buy large estates, both in Devon and Cornwall. He also owned many leases on valuable properties which brought him in a steady stream of money. Dartmouth Guildhall was formerly one of his residences, his second house being in Higher Street. He also provided money for some of the important buildings in Dartmouth. He is buried in St Saviour's Church along with both of his wives, Alicia and Joanna.

Jack B. Yeats

Jack B. Yeats (1871–1957) was the brother of William Butler Yeats, who was an Irish poet and famous writer of twentieth-century literature. Jack was a very talented artist

and whilst studying art in London he met Mary Cottenham White, a Devon artist affectionately known as 'Cottie'. They got married in 1894 and honeymooned in Dawlish, Devon. It was some years later that they moved into Coombery, a two-storey cottage with tall chimneys and thatched roof, near Strete, which is situated 4 miles south of Dartmouth. The cottage lay very close to a trout stream and this may have been why it was infested with snails. There were so many snails that he christened it 'Snails Castle'. Later this was replaced by the translation of the name into Irish, *'Cashlauna Shelmiddy'* (*Caislean Seilmide*). The snails appealed to Jack's artistic nature and he began to draw snails with towers rising from their backs, symbolising Snails Castle. This he would draw on his notepaper, envelopes and inside books. He had a dog called Hooligan (Hoolie) and together Jack, Cottie and Hoolie lived a happy existence at Snails Castle, Cottie tending her garden and feeding her hens and Jack painting local scenes, until 1910 when they moved to Ireland.

Sir Winston Churchill

Winston Churchill visited the Dartmouth Royal Naval College in 1914, arriving in the Admiralty yacht *Enchantress*. Another famous visitor, in the same year, was the wrtier Rudyard Kipling and his family.

John 'Babbacombe' Lee

A notorious person who didn't hail from Dartmouth but who worked there for some time was a man known as John 'Babbacombe' Lee, the man they couldn't hang. His name became known all over the south-west of England and was even reported on in some of the big-name newspapers of that time.

The year was 1882, and John Lee had worked for a time at The Royal Dart Hotel, Dartmouth, as a 'boot' boy. From there he went on to work at Kingswear train station and then worked as a porter at Torre train station in Torquay in 1883 and also as a footman in one of the hotels. He was found guilty of stealing from his employer and spent six months in jail.

On his release in 1884, his sister put a 'word' in for him with her employer who owned a property in Babbacombe, called The Glen. It was whilst in the employ of Miss Emma Ann Keyes, aged seventy, that she was found brutally murdered, and John Lee was accused of the crime. He was found guilty and was sentenced to be hanged. The hanging was to take place at Exeter Jail, but when he was led out to the trapdoor and the hood placed over his head, the trap failed to drop. They tried to hang him three times, but each time the trapdoors failed to open ... even with a little bit of help from the prison officers. This was a very unusual event and so after great deliberation, it was decided to give him a life sentence. He served twenty-two years of the sentence and was then freed.

It has been said that on his release he came to live with a Dartmouth publican, before leaving to live in London, where he later got married. What happened to him varies depending on which version you read, but it is thought that he emigrated to America.

Dartmouth Town Crier

Town criers or bellmen, as they were originally known, can be historically traced back to the Norman invasion of 1066. In Dartmouth their history can be traced back at least to the early to mid-seventeenth century.

The original role of the bellmen/town criers was to act on behalf of the monarch. They were appointed by the Lord of the Manor and mainly today by the Town Clerk or local council. Their duties are varied, although originally they played an important role proclaiming the news in the towns and hinterland where they lived.

In the past they were a very important part of the community, as they still are today. They patrolled the streets, calling out the time of the hour and the state of the weather, followed by the words 'All is well'. They also had the power to put people in stocks for misdemeanours, regulated the curfew and generally made the town safe from criminals and threat of fire by making sure hearths were covered and bakehouse ovens were extinguished. They would assist with the selling of surplus food at markets or even the selling of wives, brought to the market by their husbands when they had grown tired of them.

Distinctive by their loud voices and traditional handbell ringing, they are a very striking figure. Some criers use other instruments such as a drum or a horn. In Scotland, in the nineteenth century, one woman known as Beetty Dick used to bang a wooden spoon on a trencher to attract attention.

Les Ellis is the current town crier of Dartmouth, a role he has held for fourteen years. He first took up a temporary role at Galmpton Gooseberry Pie Fair in 2003, when previous town crier Peter Randall became unwell. Peter took up the role of Dartmouth town crier on 15 December 1982, and continued in the role for the next twenty-two years.

As a new committee member of the Gooseberry Pie Fair and whilst also beginning to 'live the dream of retiring to Devon', Les was approached by the local postmaster/treasurer who asked him would he like to stand in for Peter. He agreed to 'give it a go'. Sadly, Peter died the day before the fair on 3 July 2003 and Les continued in that role for three years until he was invited by a local builder, over a pint of ale in The Ferry Boat Inn, Dittisham, to apply to be Dartmouth's town crier.

Supported and recommended by the Dartmouth Chamber of Trade, Les was appointed as Dartmouth's official town crier by the Town Council in April 2007.

Les is originally from Plymouth, and from 1971 to 2001 was a detective at Scotland Yard. After retiring from the Metropolitan Police, he moved back to Devon in 2002 to live in Galmpton where he had holidayed on many occasions with his wife Liz, and had fallen in love with the place. He wears the customary eighteenth-century regalia, tricorn hat with

Town Crier in
'Naval-look' regalia.
(© Les Ellis)

ostrich feathers, tunic and waistcoat, with breeches, white stockings and buckled shoes, all in the town's colours of red, blue and gold. He sometimes wears a 'Naval look' regalia which has been specially made for 'Mayflower 400', the celebration of the Pilgrim Fathers leaving England via Dartmouth in 1620.

On 4 August 2018, the annual National Ancient and Honourable Guild of Town Crier Championships were held on the lawn of the outer moat next to Salisbury Tower at Castle Hill, Windsor Castle. This was the first time that permission had been granted to hold such an event at this location. Thirty-eight criers took part and Les was judged 'Best Dressed Crier', wearing the newly made 'Naval look' regalia. He has since won this accolade on several more occasions at various competitions and carnivals in the South West.

A Dartmouth resident of many years told Les about a local fish merchant called Mr Sanders, who would ring his bell and when the people heard him, they would stop and listen to what he had to say.

In 2013, one of Dartmouth's oldest inhabitants, Jimmy Newell, reached the age of 100. Les was asked to read a letter that had been sent by the Queen. After proclaiming the letter to the invited birthday guests, Jimmy stood up and made a little speech of his own: 'Ladies and gentlemen, you all know Les is our town crier, but he is not just a "town crier", he is now 'the Queen's messenger'.

Les is a very valuable asset to Dartmouth, not only as the town crier but as an ambassador and director of the visitor centre. He is well known and well liked, two very precious assets that make up a town crier.

One of the earlier Dartmouth town criers was a man called William Drake, who in 1824, at the age of seventy-seven, died. He lies in the graveyard at St Saviour's Church. According to the inscription on his headstone he was the borough town crier and Town Sergeant for forty years. He was also a Mace Bearer to the Mayor of Dartmouth Town

Town Crier Les Ellis with his Consort, in Dartmouth colours regalia of red, blue and gold. (© Les Ellis)

Council. In 1817, at the age of seventy, he married Agnes Efford (12 May 1799) aged eighteen. They had a son named Robert who died at the age of nine weeks and is buried with his father in the same grave.

In accordance with tradition each 'cry' begins with 'Oyez, oyez, oyez', or 'Ouii', French for 'Hear ye' or 'Listen up'. The cry always finishes with 'God save the Queen'.

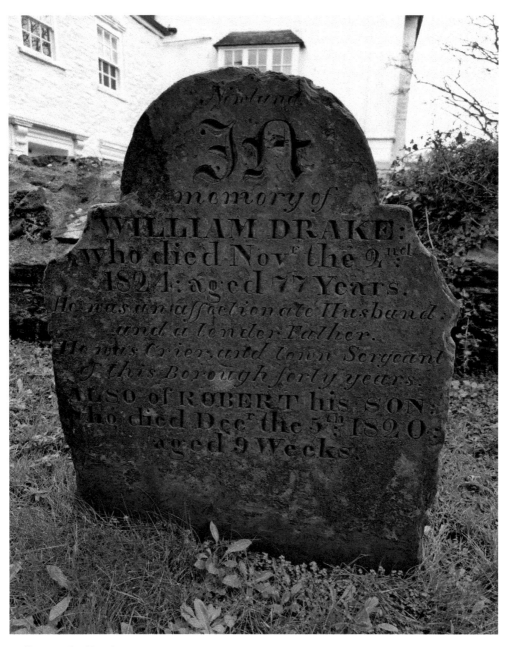

William Drakes' headstone.

5. Dartmouth on the 'Big Screen'

The Palladium Electric Theatre was located in Hanover Street in 1914, where a wall acted as a screen which was painted white and a man played a piano, to provide some background music. It was named Hanover Street in order to welcome the new royal line from Hanover. In 1917 Hanover Street was renamed Anzac Street. The building still stands in Anzac Street, but is no longer a cinema.

The Cinedrome Electric Theatre was located on Mayor's Avenue, at Zion Place, and by 1939 it was simply known as the Cinedrome (it is now the site of the Dartmouth Clinic). It had seating for 600 and the stage was 20 feet in depth, which was adequate for occasional variety performances. By 1947 the name of the cinema had been changed to The Maxime and in later years became known more simplistically as The Cinema. In the early 1970s the lease of the cinema was sold to Mr C. C. W. 'Charles Scott' of Scott Cinemas. The cinema closed for refurbishment and during that time a new name was sought for it. The name that seemed to be the most popular was The Royalty. In April 1973 it opened its doors again as The Royalty and remained open until the summer of 1986.

Film-makers seem to have been drawn to Dartmouth, and it's not hard to see why. It is brimming with history and atmosphere. It is the perfect backdrop for historical films or ones that have a connection with the sea. The upside of the this is that the film companies and crews bring much-needed revenue to the town. Some of the actors and members of the crews have even returned to Dartmouth after filming and made it their home. A few of the films and series filmed include the following:

The French Lieutenant's Woman, 1981, starring Meryl Streep and Jeremy Irons, was filmed in Kingswear. Scenes were filmed on Fore Street, the Steam Packet, Kingswear station and the Swan Hotel. Some of the filming took place in Bayard's Cove, Dartmouth. It was adapted from the novel written in 1969 by John Fowles. For the scenes that were shot in Kingswear, paving stones that were made of rubber and made to resemble cobbles had to be used, to make the scenes more authentic.

The Sailor Who Fell from Grace with the Sea, 1976, starring Kris Kristofferson, was filmed in Bayard's Cove. It is said, anecdotally, that he was taken one night to a local folk club to perform some of his songs. Whilst performing one of his songs he had to be helped from the stage as he became very emotional due to the hospitality he had received during his stay. The film was not well received by the people of Dartmouth, as it had what was thought to be very explicit sex scenes in it, something that the people of Dartmouth had not realised would be part of it.

The Onedin Line TV series ran from 1971 to 1980, and mainly featured Bayard's Cove, the old marketplace and the pottery at Warfleet. Dartmouth was transformed to represent Victorian Liverpool and many of the residents enjoyed mingling with the actors and watching the sets being prepared. This was one of the more popular series of its time,

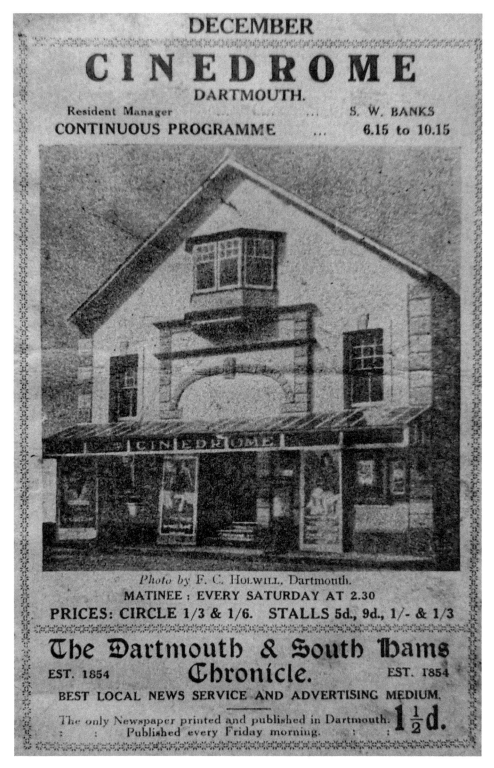

Cinedrome Flyer.

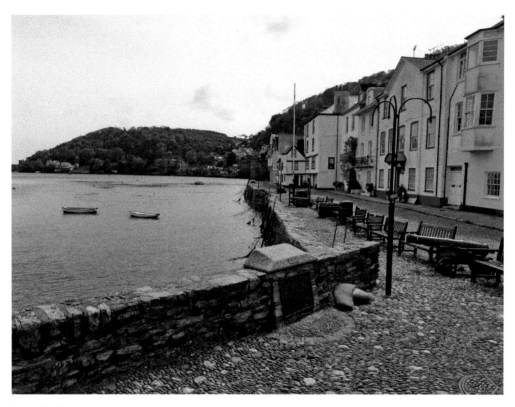

Bayard's Cove.

totalling eight series and ninety-one episodes. The ship that was used in the series is still in use today. It is called *The Kathleen and Mary* and it is one of the last of Britain's three-masted, topsail schooners. For the series it was renamed the *Charlotte Rhodes*. It was originally built in Connah's Quay in 1900 for a Captain John Coppack, and used for cargo trading, mainly around the Irish Sea.

The Coroner was a series of twenty episodes which ran from 2015–2016, filmed in Dartmouth.

The *Miss Marple* film of 1992 was shot on Paignton and Dartmouth Steam Railway.

Nothing But the Night (1973) starred Christopher Lee, Peter Cushing and Diana Dors.

Churchill: The Hollywood Years (2004) starred Miranda Richardson and Christian Slater, and was filmed at Kingswear railway station. Unfortunately, this did not do well at the box office, but many of the town's residents were used as 'extras', which they found great fun.

The System (1964) starred Oliver Reed and Jane Merrow, and was shot on the Dartmouth Lower Ferry.

Treasure Island (1977) was a miniseries shot in Dartmouth starring Alfred Burke.

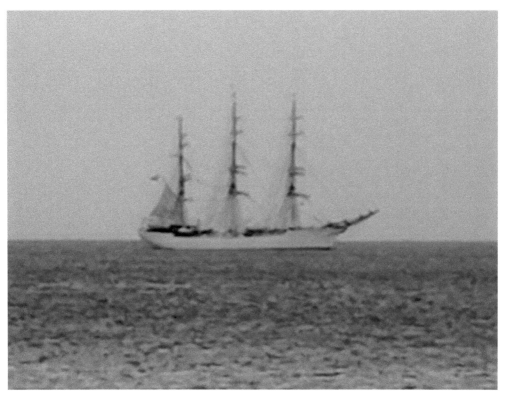

The ship used in the filming of the *Onedin Line* series, seen recently crossing the bay at Torbay, Devon.

Photo taken during shooting of the *Onedin Line*. (Totnes Image Bank)

6. Mysterious Dartmouth

The Phantom Ship of Warfleet Bay

'Twas the very witching hour of night,
When graves give up their dead,
And churchyards yawn and Ghosts come forth
This Earth, once more, to tread.
I stood upon the Viaduct
That faces Warfleet Bay,
I saw a weird a ghostly sight
That haunts me night and day:
Within the Bay where now lies sunk
The Spanish man-of-war,
A Phantom Ship appeared in sight
Full rigged from aft to fore,
Her men were gathered on the deck,
The Captain where was he?
Upon the main-yard arm he hung
As dead as dead could be.
Full three times passed that Phantom Ship
Before my startled eyes,
A blue flame seemed to light that corpse
That hung 'twixt seas and skies.
Unearthly fire enwrapped the ship,
A ghostly fearsome light,
Then 'neath the circumambient wave
She vanished from my sight.
(St George)

Sudden Death at Blackawton

An inquest was held into the death of a sixty-four-year-old lady who had been found dead in her bed. The inquest was held on Friday 8 January 1909. Her son had identified the body. He told the inquest that he went off to bed at around nine o'clock on the Sunday night and that his mother had come to him to ask him the time. It was the next morning when her other son asked for the keys for the granary that he was told that his mother had not got up yet. On entering his mother's room, he found her dead in her bed. A witness said that the mother had told her that she had seen 'something in white' on the road and that she had tried to speak to it but there was no answer and then it suddenly disappeared. A servant stayed in the room with her that night as she felt frightened.

Ghostly galleon. (© Hazel Brown)

When the servant awoke the next morning she said that the lady appeared to be still asleep and did not want to disturb her. The servant then went downstairs and told the son that his mother was not down yet and so he went upstairs to check on her and found her to be dead. The post-mortem determined that she had died from heart disease ... but could it have been something else?

Skeletons Discovered in Garden

A new house being built at One Gun, near Dartmouth Castle, uncovered a very dark secret. Whilst the gardener was busy in the garden with his spade, he struck a human skull. A number of skeletons were then found to be buried in the garden. This resulted in an unofficial archaeological dig being carried out and fourteen skeletons were eventually found. It was thought that they may have been buried there sometime after 1600. This may have occurred due to the churchyard at St Petrox Church being too small for use other than for those people who lived in the parish. There were no apparent signs of injury which could have suggested a violent death. The St Petrox register was examined at the Devon Record Office and revealed some interesting notes located in the back of the register regarding the burial of foreigners. One of the notes referred to a Frenchman buried on 7 December 1676 at One Gun who had been on a ship from the West Indies. Other interesting finds were buttons made of animal bones and fragments of clay pipes.

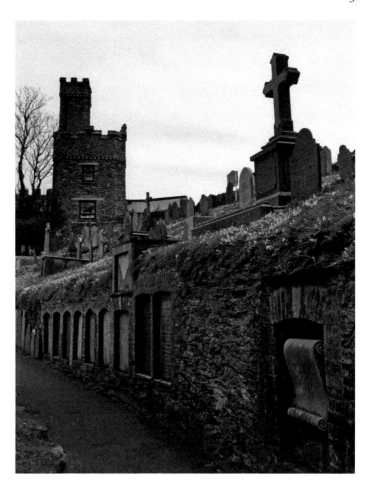

St Petrox graveyard.

The name 'One Gun' was used in early times for the site in which the skeletons were found. This was because it was once used for gunnery practice when cannonballs were fired across the river to the Kingswear side of the Dart, which at that time was deserted.

Continuing the theme of 'skeletons in the garden', at Paradise Point, Warfleet, many years ago stood Paradise Fort. This building was demolished to make way for a new house which was known as Ravensbury. This was around 1860 and the new house became the home of many notable Dartmouth residents. It was whilst excavation work was being carried out in the grounds of the house that five skeletons were found buried. These turned out to be the remains of sailors taken from a Dutch ship who had perished from the plague in 1774.

When the old jail was being demolished in 1825, another gruesome discovery was made, again involving the number five. This time five skeletons were found, four facing upwards and one facing downwards. The opinion of Percy Russell, antiquarian and founder of Dartmouth Museum, was sought, and he thought that they may be 'monks of the Premonstratensian Order belonging to the fourteenth-century Chapel of Holy Trinity, on the site of the present church of St Saviour's' (Russell).

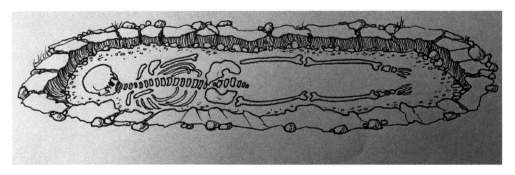

Skeleton. (© Hazel Brown)

The old gaol, demolished 1825. (B. Morris Collection)

The 'Pink' House, which used to be the home of the prison Governor.

Dartmouth's First Murder Trial, 1919

This is the tragic story of an American called Raymond Timmins who was employed as the chief engineer aboard the *Western Maid*. Mr Timmins, along with a multinational complement of seamen, joined the *Maid* in Baltimore. This mixture of cultures and backgrounds meant that there were some who did not get on too well with each other. Amongst the crew were two Irishmen: Mike Flaherty and Joe Geary. These two men took a dislike to the second engineer, Tony Kelly.

Throughout the crossing the men continuously argued, which resulted in Kelly, a forty-seven-year-old American, taking four days' pay out of the Irishmen's pay due to their laziness and bad attitude. Timmins thought that the matter had been dealt with but Flaherty and Geary thought differently, and made a vow to get even.

On 10 June the *Maid* arrived at Dartmouth and the crew were desperate to get off the ship and go into the town. The two Irishmen did not wait for permission and took off into the town to taste the local beer. Kelly and Timmins, on the other hand, decided to have a more relaxed shore leave and left the ship sometime later. They went for a walk and before returning to the ship tried a glass of the local ale. After this they made their way to the embankment where they were to wait for a boat to take them back to the *Western Maid*.

Soon after, Flaherty and Geary arrived and were in a drunken state, shouting abuse. This angered Kelly but Timmins managed to calm him and got him onto a boat and returned to the ship. The two Irishmen followed after them and continued to threaten

them. Timmins was scared and asked the captain to lock the Irishmen away in the brig, but this was refused.

Timmins returned to his cabin and took out a revolver. He ran to the saloon where Kelly and the two Irishmen had begun to fight and a knife was produced. At this point, Kelly grabbed the hand in which Timmins held his revolver, and it went off, accidentally killing Kelly. This immediately sent Timmins into shock and out of fear he shot at Geary, which hit him in the back.

Geary was taken to the Cottage Hospital in Dartmouth for treatment and the next day Dartmouth held its first murder trial. Eventually, after all the details of the fateful night were heard, Timmins was acquitted. This was because any witnesses had now left the country, on the ship, and Geary was making a good recovery.

A Case of Witchcraft

There are many cases of witchcraft in the villages of Devon and surrounding counties. There is evidence of a case of witchcraft in Dittisham, close to Dartmouth, where up to three young women became ill. Their mothers were deeply worried about them and thought that they must have been hexed by an ill-wisher. They contacted a wizard who lived at Teignmouth. He said that the women were 'deeply wounded' and that he could cure them but it would cost them money. They gave him a good amount of money but the young women remained unwell. He eventually decided that nothing could be done for them.

The mothers then contacted a witch in Dartmouth and she demanded the sum of four pounds, which was to be kept secret to 'ensure success of the venture'. The young women did become well again and the witch was credited with the cure and wanted payment. Unfortunately, although the mothers tried they were unable to raise such a large amount and asked a friend to go and speak to the 'white witch'. He confronted the witch and threatened to put her before the magistrates if she didn't retract the payment. The witch became very scared and she relinquished her claim to the four pounds and even returned part of the money she had already taken.

DID YOU KNOW?
It is thought that the name Dittisham may have originated from an invading Saxon called Dida, a corruption of Dida's ham, or Dida's home.

The Scolding Stone, Dittisham

In the middle of the River Dart, near Dittisham, stands the Scolding Stone (also known as the Anchorstone). It is said that if a husband's wife had been unfaithful they would be taken out to the stone and tied to it as a punishment, to be ridiculed and humiliated. It has also been said that a husband from Dittisham could sell his wife if he had grown tired of her.

The Anchor Stone, Dittisham. (B. Morris Collection)

The Mouse in the Ten-shilling Note

The Seven Stars in Smith Street is reputed to be the oldest pub in Dartmouth. It is said that it is haunted by a ghost who moves around the building at night and also likes to smash glasses for some unknown reason.

The Seven Stars also has another strange secret: a mummified mouse wrapped up in a ten-shilling note. The mouse had been found hidden in the wall of the main bar area after renovations were carried out following a fire. It is now kept in a nook in one of the timber beams above the bar. Legend says that if the mouse is removed from the building it will no longer be protected by its magic.

It is not known who put the mouse there, but is thought to date from around the 1960s when a ten-shilling note would have had more worth than fifty pence in today's currency. Was it placed in the wall to ward off any future infestation of mice or as a magic charm to protect the building, no one seems to know. One thing is certain: the staff are adamant that it will not be taken out of the building for fear of bringing bad luck either to them or the premises.

The River Wraith

Dartmouth has a wealth of ancient woodland which descends ever downwards towards secluded creeks and the flowing River Dart. During the daytime it is a joy to ramble through its untouched countryside, watching wildlife as it goes about its daily chores. Wild flowers nod majestically in the glorious sunshine as the Dart continues to flow between heavily wooded banks. Birds soar overhead following the flow of the river into secret coves, perhaps used by smugglers in bygone years.

The Seven Stars, Smith Street.

The mouse in the ten-shilling note. (© Ken Taylor)

The beam over the bar which contains the mouse.

When the day draws to an end and the darkness of night closes in, it starts to take on a very different atmosphere. Walking through the darkened woods begins to bring on a feeling of apprehension, as strange rustling noises can be heard from the shadowy undergrowth – perhaps just a fox looking for its nightly feed, or maybe a curious nature spirit. Eerie mists rise like smoky portals to other worlds, watching and waiting. What these mists are is a matter of opinion. The scientist amongst us may say they are merely caused by water vapour and nothing more. The more spiritual amongst us may think they are something very different, believing they are 'soul mists', some form of ectoplasmic mist emitted by lost souls or spirits.

Mysterious mists have been seen to rise from the ground and can also appear over water, some rising into tall columns floating on the surface, and at other times forming long barriers, enticing you towards them, leaving you to worry whether you will eventually emerge out of the other side.

In the book *Dartmouth Ghosts and Mysteries* written by Ken Taylor, Phil Sheardown told of a strange encounter with a water wraith whilst canoeing on the River Dart. Since that time Phil has experienced further encounters: 'In the daytime I have seen misty wraiths, floating horizontally against the great trees on the high steep bank beside the river, writhing gently as if hungry or in pain.' He went on to say that after the original incident, in the early hours of the morning, he was on high ground inland and stopped to look across the valley. Half a mile away three such misty wraiths were standing tall, close by the church and as he watched, one by one, each drifted away and dispersed.

Phil concedes that these events could easily be explained as weather anomalies and that 'Superstition, coincidence and luck sometimes go hand in hand.'

Secret Tunnels

Dartmouth may have more tunnels than are accounted for here. One tunnel is traditionally said to lead from St Saviour's Church in Anzac Street to one of the old houses in nearby Smith Street. It is said that monks clad in dark-coloured robes haunt the secret passageway and are guardians of a precious secret that has been lost over the centuries.

Other tunnels exist at the builders' merchants Travis Perkins, at the back of the building. This area would have backed onto the river many years ago, before the reclamation of the land. Metal rings can still be seen, which would have been used to tie up boats at that time. There are different ideas about the use of the tunnels over the years. They have been used for the storage of champagne cider and probably other similar items. Parts of the tunnel date back to the sixteenth century. What it was used for at that time is unknown.

The Woman in White

The following is a transcript of an anonymous article printed in the *Dartmouth & South Hams Chronicle* on 9 August 1872.

Origins of a tunnel at Travis Perkins, Dartmouth.

The Rev. W. Stenner, Independent minister, Dartmouth, about thirty years ago, on returning home from a pastoral visit late at night, saw, to his great astonishment, a short distance from him, a tall figure in white. Could it be a ghost? And did he really behold one? Well, he would see. On the figure went with noiseless tread, and at a distance Mr Stenner followed, until it, suddenly, as it was, vanished through a door. The next morning Mr Stenner called at the house at the door of which he saw the figure vanish. The result of the visit was, one of the ladies of the house was known occasionally to 'walk in her sleep', and from sundry signs it was evident it was this lady that Mr Stenner saw and followed up the previous night. She had risen from her bed, opened the front door of the house, perambulated the streets, and returned again to her house and bed unknown to her friends. Had the vision been seen by persons of less presence of mind, a very pretty ghost story might have been the result. (From the *Leisure Hour*, Aug 1872)

The Mystery of the Cloven Hooves
This is a very strange tale from Ken Taylor's book *Dartmouth Ghosts and Mysteries*.

In or around February 1994 Stevie Rogers was confronted by a shocking sight that aroused her instinct to get away -quickly – from something so blatant in its defiance of common sense that it conjured a sense of imminent otherworldly danger.

She was alone in the snow-mantled countryside of Fast Rabbit Farm near Ash, and the sense of isolation was as profound as the silence. The snow was drifting in places, and her journey to check on and deliver hay to her sheep had taken thirty minutes instead of the usual seven or eight because she had to dig her way through the drifts. Her mid-morning journey was part and parcel of the arduous life expected by anyone who loves their livestock, but what she found in the field was not part of the natural order of things.

There are no lanes in that part of the farm, and she was driving around the edge of an empty 20 acre (8.1 ha) field immediately before the field with the sheep when she noticed a trail of footprints in the snow. The tracks had been left by a creature with cloven hooves about the size of the palm of her hand, which had approached the gate. A glance at the undisturbed snow showed that the tracks didn't go past the gate – the beast should still have been standing right there in front of her.

When she looked to see where it had come from she saw that the spacing was like that of a pacing man rather than a four-legged animal and, rather than meandering, it walked a dead straight path. She followed the tracks back out towards the middle of the field, about a hundred feet or so (30m), where they began – as abruptly as they'd stopped at the gate. Surrounded by pristine snow all around, the first cloven hoof print simply appeared out of nowhere.

Deadman's Cross
Heading out of Dartmouth towards Strete you come to a junction in the road, between Waterpool Road and Milton Lane. This junction is known as Deadman's Cross. A mysterious shadow has appeared on the wall of the corner white cottage. It resembles a hanging man and has been chilling some of the local residents to the bone. Ray Freeman,

in her book *Dartmouth and Its Neighbours*, has provided details about Deadman's Cross. She explained that in the thirteenth century, criminals were hanged and their dead bodies left in chains at the site for many days to deter any wrongdoers. Pictures of the mysterious shape went viral on the internet as people tried to make sense of how or why it was there.

The outline seems to have been caused by the high midday sun casting shadows on the wall, shadows which have been caused by the road signs attached to a post by the side of the wall. This had given the effect of someone hanging from a rope. A spokesperson from the Dartmouth Museum commented that hangings were common at Deadman's Cross in the 1400s, which makes it all the more strange that the shadow should actually resemble an effigy from its past history.

Shadow of the 'hanging man' at Deadman's Cross. (© Les Ellis)

7. Working Life in Dartmouth in the 1800s and 1900s

For some the working life in the 1800s was not as profitable as it was for the wealthy merchants of the town. A carpenter by the name of Reuben Lidstone was working on some wooden church seats and decided to leave a message hidden away, telling of the poor existence some of the people of Dartmouth had to endure. It read as follows:

> When you see this remember me that I am not quite forgotten ... that the times are very bad ... for working men get fourteen shillings a week, and flour five pence a pound, potatoes one shilling a stone ... and one half of the men can get no work. You may depend their pride is come to grief, for instead of ducks and geese they are forced to eat sheep's head. (Black, 1910)

Another Dartmothian who was also struggling to find work and support his family was Corporal T. W. H. Veale VC of the Devonshire Regiment. He had fought in the Battle of the Somme in 1916 and had received the Victoria Cross for rescuing an officer who had been wounded some 50 yards away from the enemy. He found him lying amongst some corn and dragged the officer back to a shell hole. After finding some men to help him and whilst trying to carry the officer to safety, one of the men was shot. The heavy gun

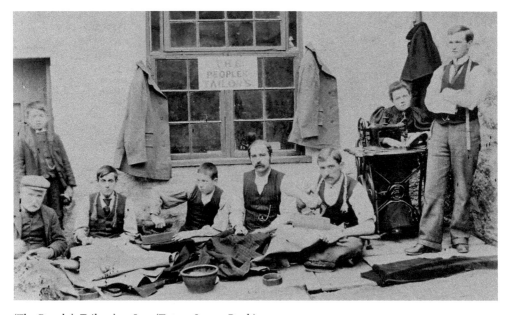

'The People's Tailors' c. 1895. (Totnes Image Bank)

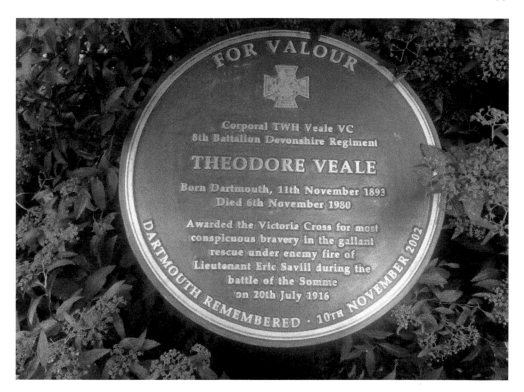

Plaque dedicated to Corporal T. W. H. Veale.

fire continued and it was decided to take the officer back to the shell hole. It was dawn when Veale continued his rescue mission, but he and his volunteers were spotted by the enemy. He quickly ran back and grabbed a Lewis gun with which he managed to cover the rescuers, enabling the officer to be carried to safety. For his bravery he was awarded the Victoria Cross by King George V.

Veale returned to Dartmouth where he received with a hero's welcome. At the end of the war it was hoped that a war hero would be looked after, and that the adage 'Britain would be a land fit for heroes to live in' would be adhered to. Unfortunately, this proved not to be the case and after working for a time in the local building trade, where work was limited, he moved to London, where he hoped there would be more opportunities to find work. This proved fruitless and the following quote from the *Western Morning News* was reported:

'VC but no job. Ex-corporal seeks job. What offers? Owns VC (Victoria Cross). TT. Non-smoker'.

It is thought that this sad advertisement was posted by Veale himself and showed his desperation to find work. He was offered short-term employment offers with various people and at the outbreak of the Second World War he once again joined the forces and became a dispatch rider. After serving his time with the regiment he looked for work again, but times must have been very hard for him and his family as his war medals, including his VC, were spotted in a dealer's window for sale. Luckily they were

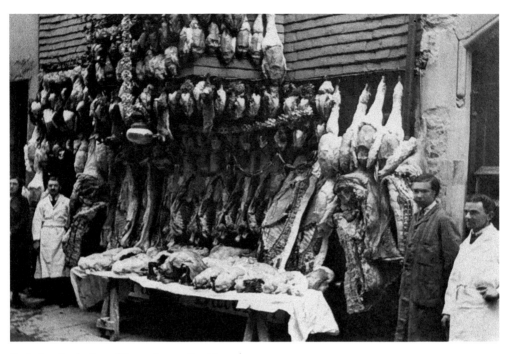

Early butcher's shop. (Totnes Image Bank)

successfully purchased and given over to the Devonshire and Dorset Regimental Museum, to be displayed in their rightful place.

The Kingswear Steam Laundry, Waterhead Creek, originally started life as Popes Brass and Iron Foundry, 1866–73. It later became Polyblank's Shipbuilders and Engineers from 1874–81, and then Mitchelmore's Steam Laundry, 1883–1971. In the war years it became the laundry for the British, American and French forces that were stationed in the area. During this time it employed thirty-five girls, who for six days a week started work at 7.30 a.m. and finished late in the evening. Although the laundry initially only catered for the forces, eventually in 1905 they agreed to accept laundry from visiting yachtsmen, which brought extra work and much-needed money into the area. Around the same time a new laundry company called the Dartmouth Sanitary Laundry opened in Dartmouth, which was greatly welcomed as there were no other laundry facilities available there. Again, this created more jobs for the town.

In the 1870s coal bunkering was a major industry. Coal from Wales and the North East was shipped to Dartmouth and stored in hulks which were moored on the River Dart. Steamships were now beginning to travel to further destinations but were held back by their lack of bunker or coal storage capacity. Certain ports were designated as bunkering stations, a place where a ship could sail in and 'top up' its coal reserves. Groups of men would wait at Bayard's Cove until a signal from a person placed above the harbour would instruct them to get into the gigs, which were already waiting, moored to a ladder on the quay wall. They would then race to the hulk and wait for the ship to arrive. The task of filling the ships bunkers with coal would then begin.

During the First World War, the coal lumping business began to diminish and many of the menfolk of the town began to get disillusioned about the lack of money and what the future held for them. Some joined the Devonshire Regiment, whilst others joined the Dock, Wharf, Riverside and General Workers' Union, which improved their chances to gain better wages from their employers. The war affected Dartmouth greatly as there was a massive reduction in ships visiting the river. This had a 'knock-on' effect to the men who worked on the river, such as the coal lumpers, who made their living coaling the ships. Both the dock workers and the lumpers only received pay for the work that they did, and as work became scarcer, so it affected the wage that they received. Their wages were minimal, but their employers began to reduce their wages even more, as they too were feeling the pinch.

Shipbuilding and boatbuilding provided some employment, along with boat repairs, but as the land started to be reclaimed back from the river, some of these boatyards began to disappear.

Since then, tourism has been one of the major sources of labour, which provides good income. Cruise ships and super yachts frequent the Dart, along with holidaymakers and tourists, who travel from all over the world to the visit the town and stay in local accommodation.

8. Miranda, the Mermaid of Dartmouth

Perched on a rock above the River Dart, gazing wistfully out to sea, sits a beautiful bronze sculpture of a mermaid. She watches silently as the sea ebbs and flows into the Dart, bringing with it myriads of fish watched over by hungry gulls. She was created by the very talented Brixham-based sculptor Elisabeth Hadley, who in 2005 was commissioned by a local Dartmothian to create the sculpture, as she wanted to give something back to Dartmouth, the town that she loved. The way in which the mermaid has been sculptured would suggest it was created by someone who had an affinity with water. The fluidity and beauty of the sculpture has been admired by many who have sailed into the River Dart. The name Miranda was given to the sculpture by the lady who commissioned it. It is taken from the 1948 film with the same name, which starred Glynis Johns as a mermaid who gets hooked up on a fishing line by a young doctor. She pulls him into the water and keeps him in her underwater cavern and doesn't agree to release him unless he takes her to see the city of London.

I spoke to the creator of the sculpture and asked her if she had always been drawn to the sea. She said that she had always loved to be in or around water, either swimming or kayaking, which is a big part of her life. Elisabeth worked on the sculpture in the studio at her home in Brixham, firstly making sketches, and then finally finishing it around two months later. In 2006, the mermaid was moved to her resting place by the Dart. Elisabeth regularly kayaks along the Dart, no doubt watched over by her beautiful creation, Miranda the Mermaid of Dartmouth.

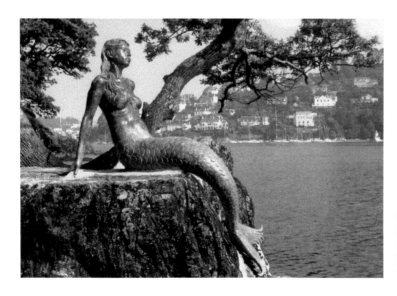

Miranda, the Mermaid of Dartmouth. (By kind permission of Elisabeth Hadley)

9. Dartmouth Freemasons

After walking under a large stone archway, and entering through a blue door, you arrive at Hauley Lodge, the meeting place of Dartmouth's Freemasons, the 797th registered lodge in the country. The building was once owned by Charles Seale Hayne, who was not only a businessman, but also a Member of Parliament. After his death in 1903, the house, which was being rented to the masons, was sold to them by a member of the family for the princely sum of £462.00. The lodge is named after John Hauley, a past mayor of Dartmouth who was re-elected fourteen times and also a Member of Parliament for the town. He was also a very skilled mariner and was a very important benefactor to the people of Dartmouth.

On the upper floor of the building is the masonic temple. The room is lined with beautiful wooden panels, which have been coated with red lead on the reverse side so that they do not get affected by dampness, as this building stands on reclaimed land.

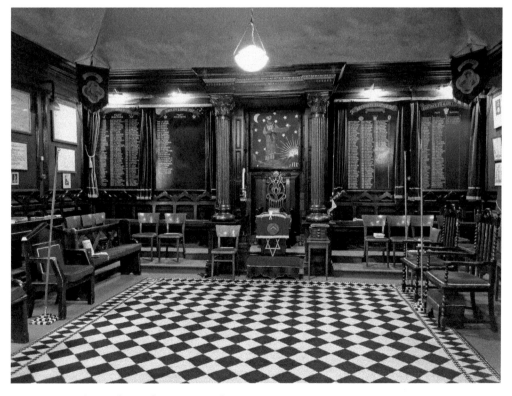

Masonic Temple, Hauley Lodge, Dartmouth.

There is a richness and elegance about the room, and also a feeling of grandeur. The floor is covered with a black and white-chequered carpet, representing good and evil or lightness and darkness, and royal blue seating makes a striking contrast. The Worshipful Master's chair is placed on a plinth at the front of the room, with two beautifully carved pillars either side of it. The chair is ornately carved as befits its importance. The panelled walls are offset against the ceiling, which is adorned with golden stars. In 1924 the Brethren were asked to donate money to the lodge to help refurbish it. Each of the Brethren who had donated money was represented by a gold star, which was then painted onto the ceiling. For a small donation a small star was painted, for a large donation a larger star was painted. The 'all-seeing eye' is central in the ceiling, which is symbolic of the Supreme Being and is a reminder that 'they', the masons, are always being watched and judged by him.

In the 1930s it was a dangerous time to be a Freemason. Hitler was convinced that they were dangerous and posed a threat, and thought to be part of a Jewish conspiracy. He became convinced that one of the reasons that Germany lost the First World War was due to the Masons. During this time of persecution many of them were put to death and this led to them going 'underground' and becoming very secretive about their meetings. This may have been the reason that it has always been thought of as a secret society.

Symbolism plays a big part and architectural tools are part of this, the tools of the medieval operative stonemason. The square represents morality, to square their actions.

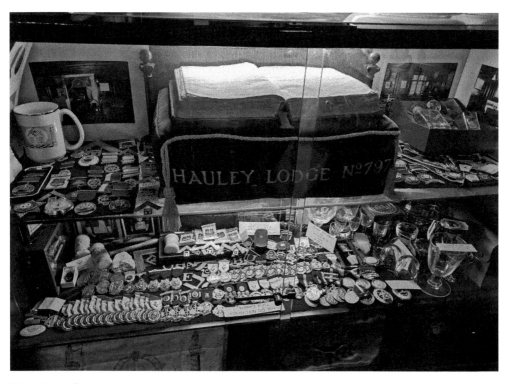

Masonic artifacts.

The compass represents the realm of the spiritual eternity, of infinite boundaries. Sometimes there is a letter 'G' in the centre of the compass and square symbol, which is said to represent God.

There is documented evidence to say that the Freemasons were founded in 1717, but it is widely thought that the Masons can be traced all the way back to Solomon's Temple. They have secret handshakes and gestures, which are different at each lodge, and these identify them. They wear a blue sash, white gloves and an apron.

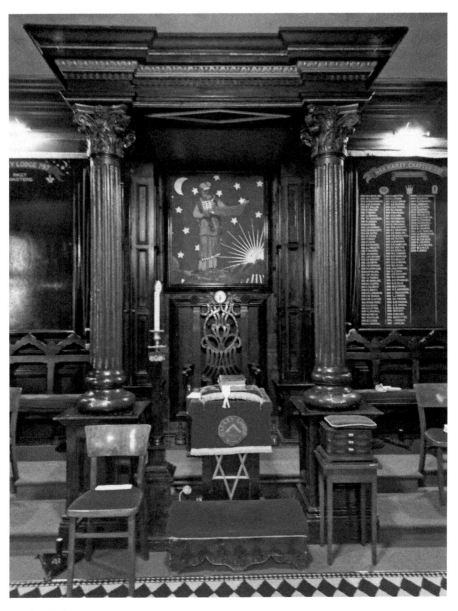

Hauley Lodge.

The Masons are an important part of the community, donating money through their own devices where it is needed. They have donated money to many of the local charities, as do other lodges throughout the country. I have recently been invited to meet Worshipful Brother and Secretary of Hauley Lodge Mike Humphreys, who kindly showed me inside the temple and allowed me to take photographs of the beautiful interior. He said that the Masons are 'not a secret society, but a society with secrets'. He also explained that many years ago people were not all able to read and write and so this may be why the various gestures and handshakes were created. Mike also said that the Dartmouth Freemasons are hoping to be part of the Mayor's Sunday Parade this year, which will be held in Plymouth. Hopefully this will help to show all concerned that they are not the

An example of a Masonic mark left on the wall of a building in Dartmouth.

secretive shadows that meet in dark rooms, performing all sorts of strange rituals. It is true that they do have rituals, and they may seem a little odd to the uninitiated, but they are just part of the mason's creed. It may be that after Dan Brown's book and the film *The Da Vinci Code*, people may feel a little bit hesitant of meeting with them, but the reality is very different. It is true that in the past you had to be invited to join the Masons, but today it is much easier to join.

There have been many famous masons over the years, including Sir Winston Churchill, Sir Arthur Conan Doyle, Rudyard Kipling, King William IV, The Duke of Wellington, and Napoleon, who was said to have had the black and white chequer design of good and evil on the floor of the cabin in his ship. So, as you can see, there is quite a diversity of characters, and these I have mentioned are but a few.

Masons' marks can be seen in various places around the town. There are several in St Clement's Church, Townstal, and one on the wall to the right of The Angel restaurant, which is situated on the embankment. Perhaps you can find more as you travel around the town. I extend many thanks to Worshipful Brother Mike Humphrey's for taking the time to show me around the lodge and explaining about the valuable work that the Freemasons do for the community.

10. The Bank of Dartmouth

In the early part of the nineteenth century, Warfleet Mill was used to produce the paper for the Dartmouth Bank notes. Arthur Howe Holdsworth, an eminent Dartmothian who was the last Governor of Dartmouth Castle, owned the mill. He managed to perfect a way of using cheap rags, which were plentiful, and lightly blending the colour which diffused from them into a suitable paper to make banknotes for the Dartmouth Bank. Arthur's brother, Henry Joseph, established the bank, but unfortunately it went bankrupt and so the banknotes became worthless.

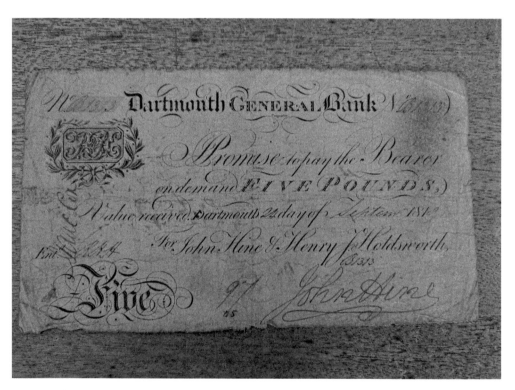

An example of a Dartmouth Bank note. (B. Morris Collection)

11. Hallsands: The Village That Fell into the Sea

One of the earliest references of a settlement at Hallsands dates back to 1611.

Today, all that remains of the village are the ruins of what was once a small thriving community of fishermen and women. It is now deserted. What was once cottages and an inn have been ripped away by pounding waves smashing their way in, causing the frightened villagers to flee for their lives.

Looking at it now, it is hard to imagine the days when clinker-built boats, made from the finest elm, lay on the beach, loaded with crab pots made of willow, along with various fishing nets. All the villagers helped to launch the boats, even the children, from the beach and then helped once again to bring them back up later. When the sea was rough, it was a dangerous task to try and catch the rope with which to guide the boat back to shore, so for this purpose dogs were sometimes used. A breed known as Newfoundland was very popular; they would swim out towards the boat and get the line, and then swim back, which then enabled the villagers to get the boat safely onto the beach again.

Many years ago, pirates and smugglers freely roamed the high seas and the coastline, raiding and bringing mayhem wherever they went. This came to an end with the hanging in chains of the pirate Henry Muge in 1581 at Start Point.

After this time the village, along with others along the bay, started to grow and by 1891 there were thirty-seven houses, a pub known as The London Inn, a shop and a chapel. The population of the village at that time was 159, and life was hard. There was much disease, sanitation was poor, and if the fishing was scarce, starvation would follow.

Life in the village continued along normally until news reached that the Admiralty had decided that due to a growing fleet, an extension to the Keyham Yard in Plymouth would need to be made. They produced a plan to commence dredging shingle from the beach at Hallsands and Beesands, at a rate of 1,600 tons a day. There was a problem with this, in that the shingle provided a natural barrier for the village from the sea and to remove this would make the village very vulnerable to storm damage. The villagers protested, saying that it was a dangerous proposition, but initially their protests fell on deaf ears. As more of the shingle was removed it was clear that the natural sea defence was slowly being taken away. Not only this, the daily use of the dredgers interfered with the ability to continue fishing, which the village depended on, not only for their own use but as a means to make some much-needed money. Eventually, their protest was listened to, and the dredgers moved on, but by this time too much shingle had been removed and it proved to be catastrophic for the village.

In March 1901, a storm hit the village, dropping the level of the beach by 7 feet, causing damage to the road which lay along the front of the cottages, between them and the beach. This began to worry the villagers. If this had happened to the road it could easily happen to their homes.

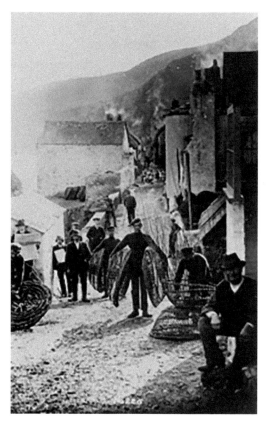

Hallsands. (Totnes Image Bank)

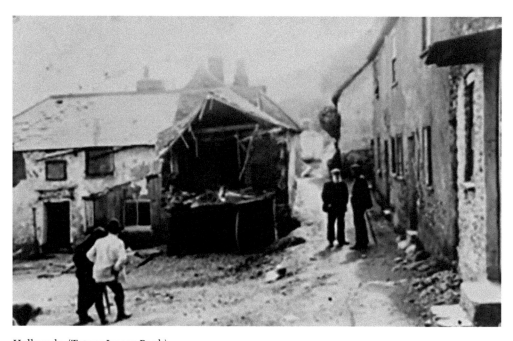

Hallsands. (Totnes Image Bank)

They were right to worry. Two further storms in 1903 and 1904 began to undermine the village, doing much damage to walls and foundations. The second storm was more severe and brought further damage, causing some of the villagers to flee their homes and spend the night at neighbouring Beesands. By this time the access road to the village was so badly damaged that the only way to enter was by a single plank. Eighteen of the cottages had been damaged beyond repair and the level of the beach had fallen by 12–19 feet and parts of the London Inn had been washed away.

Over the next few years repairs were made to the cottages, but some had to be demolished. Hallsands had paid a terrible price, mainly due to the earlier persistent dredging, but when dredging for the naval yard stopped, material was still being taken away from the bay for local building projects and used for aggregate, even with the knowledge of what had already befallen Hallsands – a case of profit over lives.

The final death knoll came in January 1917. In the days leading up to Friday 26 January, the weather changed from a gentle offshore breeze, to gale-force winds, along with an unusually high spring tide. The heavy seas crashed forward breaching the sea wall easily, continuing on its way to smash into some of the cottages, crushing them and terrifying the occupants. Other homes were boarded up and sandbags laid about. Windows were shuttered, and oil lamps burned within the darkened rooms as candles guttered and blew out. The relentless waves continued to smash through windows and demolish walls. Cottages were easily destroyed and some were washed away into the raging sea.

Miraculously, no one was killed in the physical sense, but many grieved inwardly, for life as they knew it had been ripped from under their feet, quite literally.

After the storm had settled, with their homes destroyed, the villagers went off to find homes in other areas. Some of the last villagers to leave were James Lynn, Elizabeth Prettejohn and her brother William.

The Prettejohns' cottage was still intact and they lived in isolation in the ruined village for many years. William had been on one of the last voyages to Newfoundland from Dartmouth and now spent his time making a replica model of one of the ships. This replica still exists to this day and is a fitting memorial to William. After William's death, Elizabeth lived alone in the cottage for fifty years. She preferred to stay there with her hens and memories. She was one of the last survivors from the village, a way of life that most of us would consider too solitary and simple to endure. She lived in her cottage until 1964 when she was eighty years old. Personally, I admire her.

The people of coastal villages such as Hallsands are the true shepherds of the sea. It is in their DNA, passed down through the generations before them. They are at one with the sea, and are experts at knowing how to conserve stock; they know this through an inherent instinct and this is not something that can be learnt from textbooks. They go about their fishing, landing fresh fish and crabs, supplying local businesses as well as providing food for themselves and their families. Their boats are quite small and many have lost their lives. They sail sometimes single-handedly, in small boats, and yet they are unfairly governed by the same rules as the large trawlers, that trawl their way through the same sea, devouring large amounts of fish. There are lessons to be learned from the smaller, offshore fisherman, and until they are listened to, the stocks in the local waters will diminish. We need to take heed of what became of Hallsands. We need to listen to them closely, for they have conservation on their agenda, not profit.

Chilling notice on fence overlooking Hallsands.

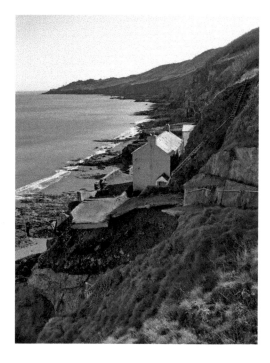

Present-day remains of Hallsands.

DID YOU KNOW?

On 9 September 1977, Naomi Christine James sailed out of Devon and singled-handedly undertook a voyage that would make her the first woman to sail around the world taking the route around Cape Horn. This made her the second woman to have ever sailed around the world solo. The voyage took 272 days and on 8 June 1978 she sailed back to Dartmouth greeted by a rapturous welcome.

Dartmouth coat of arms. (B. Morris Collection)

References

1) Historic Dartmouth
What's in a Name - Crowthers Hill (By the Dart, September 2011)
Ellis, Kate, *The Plague Maiden*; Historical Notes (Little, Brown, 2004)
New Research sheds light on Dartmouth Castle Chain: Kingsbridge & Salcombe Gazette,
 www.dartmouth-today.co.uk>article (Sunday 29 May 2016)
Scoble, Phil, *Dartmouth's Pre-history* (By the Dart, May 1; June 2012)
Scoble, Phil, *Dartmouth in the Second World War: The Port* (By the Dart, July 2013)
Scoble, Phil, *HMS Cicala* (By the Dart, May 2014)
Taylor, Ken, *Dartmouth Ghosts and Mysteries* (Dartmouth: Richard Webb, 2006) p.61
Freeman, Ray, *Dartmouth: A New History of the Port and Its People* (Dartmouth: Harbour
 Books, 1987) pp.64-66
Wikipedia: *Dartmouth History*
Wikipedia: *Dartmouth's Stream Train*
World War One in Dartmouth (By the Dart, July 2014)

2) Reclamation of Land from the River
Discover Dartmouth, *Exploring the River Dart* (July 11 2019)
Jaine, Tom, *Dartmouth: A Brief Historical Guide* (Dartmouth: The Carved Angel, 2 South
 Embankment, 1975)
Map of Dartmouth: Ordnance Survey 1911, Third Edition, Sheet 149, Survey revised 1908-9
 (re-sized from 1:63360)
Map of changing shoreline: map kindly drawn and submitted by Brian Parker

3) Architecture of Dartmouth
Christopher Robin's Bookshop to close: BBC News https:/www.bbc.co.uk:news.uk
Davies, Emily, *Ultimate seaside home is covered with millions of shells stuck to walls and
 ceilings in every room:* https://www.dailymail.co.uk (January 2013)
Freeman, Ray, *Dartmouth: A New History of the Port and Its People* (Dartmouth: Harbour
 Books, 1987) p.34,36
Freeman, Ray, *Dartmouth: A New History of the Port and Its People* (Dartmouth: Harbour
 Books, 1987) p.129
Winston, George, *The Norwegian Spy Who Jumped Tree to Tree in a 200-mile Trek to Escape
 German Captivity*; https://www.warhistoryonline.com (April 5 2016)

4) Notable Dartmothians
Devon Perspectives: John 'Babbacombe' Lee: https://www.devonperspectives.co.uk
Fisher, J., *Greenway Estate* (Devonshire: *Green Magazine*)

King, Linda, *Life and Times of William Veale, Master Mariner 1791-1867: 'The Dartmouth Robinson Crusoe'* (Dartmouth History Research Group Paper, 1999)

Wikipedia: George Bidder Parker l, George Bidder Parker lll

Woodger, L. S., *John Hawley: Bibliography*: Ref: Volumes: 1386-1421 www.histparl.ac.uk-member-hawley

5) Dartmouth on the 'Big Screen'

Filming Location Matching: "Dartmouth, Devon, England" https://www.Imdb.com>search:title

Royalty- Royalty Cinema, Dartmouth: https://royaltycinemadartmouth.wordpress.com

6) Mysteries of Dartmouth

Anon 1872, *Woman in White, Dartmouth & South Hams Chronicle*, 9 August, p3, c2 in the British Newspaper Archive 2018, The Dartmouth Chronicle, Findmypast Newspaper Archive Limited: https://www.britishnewspaperarchive.co.uk/viewer/bl/0001655/18720809/030/003Inquests Taken into Suspicious or Unexplained Deaths for the County of Devon 1874-1909. '*Something in White, Sudden Death at Blackawton'*. Genuki.org.uk/big/eng/DEV/courtrecords/Inquests. DCBA1869

Scoble, Phil, *Dartmouth's First Murder* (By the Dart, 2 December 2015)

St George (1872) *The Phantom Ship of Warfleet Bay* (*Dartmouth & South Hams Chronicle*, 29 March, p2, c1; in The British Newspaper Archive Limited) https://www.britishnewspaperarchive.co.uk/viewer/bl/0001655/18720329/0320002

Taylor, Ken, *Dartmouth Ghosts and Mysteries*, 'The Mouse Wrapped up in the Ten Shilling Note' (Dartmouth: Richard Webb, 2006) p.77

Taylor, Ken, *Dartmouth Ghosts and Mysteries*, Cloven Hooves (Dartmouth: Richard Webb, 2006) pp.117-118

Ware, Ginny, *How a Macabre Mystery Was Solved* (By the Dart, May/June 2012)

Witch Wars in Devon: strangehistory.net/2016/07/15

7) Working Life in Dartmouth in the 1800 and 1900s

Collinson, Don, *The Chronicles of Dartmouth: An Historical Yearly Log, 1854-1954*, 'Corporal T. W. H. Veale VC' (Dartmouth: Richard Webb, 2000) p.191

Smart, Ivor H., *The Dartmouth Papers lll, The Dartmouth Bunkering Coal Trade*, reproduced from 'Maritime South West ll' (1998)

Fiennes, Joslin, *Dartmouth: An Enchanted Place*, 'Rueben Lidstone' (Dartmouth: Richard Webb, 2013) p.23

8) Miranda the Mermaid of Dartmouth

Interview with Elisabeth Hadley, sculptor, Brixham

www.hadleysculptures.co.uk

9) Dartmouth Freemasons

Dartmouth Freemasons (By the Dart, October 2014)

Interview with Worshipful Brother Mike Humphreys in March 2020, at Hauley Lodge

10) Bank of Dartmouth

Fiennes, Joslin, *Dartmouth: An Enchanted Place*, 'Dartmouth Bank' (Antique Collectors Club in association with Richard Webb, 2013) p.120

11) Hallsands: *The Village That Was Lost to the Sea*

Acknowledgement to Tim Lynn for his help with information for the story of Hallsands

Bibliography

Campbell, Ginny, *Dartmouth Through Time* (Gloucestershire: Amberley, 2014)

Collinson, Don, *The Chronicles of Dartmouth: An Historical Yearly Log 1854-1954* (Dartmouth: Richard Webb, 2000)

Dartmouth's First Museum in Ancient Workshop, Anzac Street, Dartmouth. Dartmouth: Tozer & Co.

Fiennes, Joslin, *Dartmouth: An Enchanted Place* (Dartmouth: Richard Webb, 2013)

Freeman, Ray, *A New History of the Port and Its People* (Harbour Books, 1987)

Friends of the Museum Association, *Dartmouth Remembered*

Jaine, Tom, *Architectural Heritage of Dartmouth, Then and Now:* The Dartington Amenity Research Trust for the Dartmouth and Kingswear Society

Jaine, Tom, *Dartmouth, A Brief Historical Guide* (Dartmouth: The Carved Angel, 2 South Embankment, 1975)

Johnson, Ben, *Dartmouth, Devon:* https://www.historic-uk.com>dartmouth

Lomas, Robert, *The Secrets of Freemasonry, Revealing the Suppressed Tradition* (London: Robinson, 2006)

McGregor, Ian and Brian Parker, *St Clement's Church: An Illustrated Guide*

Miles Brown, et al., *A Guide to St Petrox Church, Dartmouth*

Mitchell, David, *The Word on the Street: A History of the Town Crier and Bellman* (Chester: Widespread Books, 2019)

Norman, Andrew, *Agatha Christie* (The Pitkin Guide)

Phillips, Suzanne, *Working Women in Nineteenth-Century Dartmouth* (1996)

Russell, Percy, *Dartmouth:* The Friends of Dartmouth Association (originally 1950, this edition 1982)

Scoble, Phil, *The Chronicles of Dartmouth: A Historical Yearly Log 1955-2010* (Dartmouth: Richard Webb, 2012)

St Savour's Church: An Illustrated Guide.

Taylor, Ken, *Dartmouth Ghosts and Mysteries* (Dartmouth: Richard Webb, 2006)

Acknowledgements

A huge thanks goes to my partner Brian Reid, for all his patience and support whilst I have been writing this book. Also, to my mentor and friend Ken Taylor, who has once again helped me immensely and to whom I am greatly indebted. To the many people of Dartmouth who have kindly helped me with the book. Also many thanks to Phil Scoble; Les Ellis, Dartmouth's town crier; Jan Cowling, Dartmouth Museum; Barry Morris for all his kindness spending hours looking through his fabulous collection of images for the book; Brian Parker for his superb illustration of the changing shoreline; Totnes Image Bank; Elisabeth Hadley; Mike Humphreys; Phil Sheardown; Hazel Brown for her fantastic illustrations; and also to Tim Lynn for all his help with the Hallsands story. I would also like to thank the Community Bookshop, Dartmouth Library and the Dartmouth Visitors Centre for their greatly valued input.

The author and publisher would like to thank the following people/organisations for permission to use copyright material in this book:

The Totnes Image Bank for supplying early images of Dartmouth and Hallsands.

B. Morris, from his collection of early and present-day images.

Brian Parker for his map of the changing shoreline.

Image of the Hawley Brass, St Saviour's Church, © Parish of Dartmouth PCC.

Father Will Hazlewood for giving permission to take photographs inside St Saviour's Church, St Petrox Church and St Clement's Church.

Dartmouth Visitors Centre for the image of the Newcomen steam engine.

Hazel Brown for her fantastic illustrations.

The remaining images were supplied by the author. Every attempt has been made to seek permission for copyright material used in this book. However, if we have inadvertently used copyright material without permission/acknowledgement we apologise and we will make the necessary correction at the first opportunity.